LEGENDAR

OF

FORT COLLINS

COLORADO

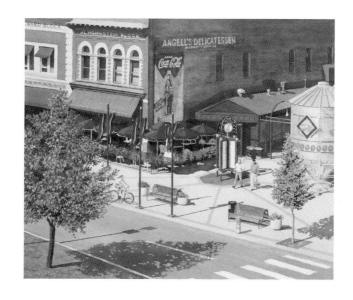

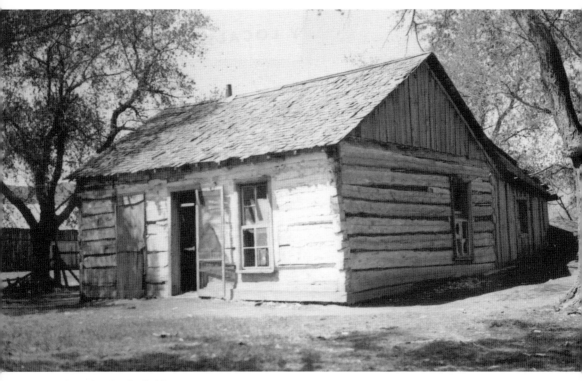

Antoine Janis Cabin
A cabin built by the man considered to be Poudre Valley's first settler, Antoine Janis, has been moved to Library Park in the heart of Fort Collins. (Courtesy of the Fort Collins Local History Archive, H04452.)

Page 1: Old Town Fort Collins
This painting of Old Town Fort Collins was done and provided by local artist Barbara Moore.

LEGENDARY LOCALS

OF

FORT COLLINS
COLORADO

BARBARA FLEMING

LEGENDARY
LOCALS

Legendary Locals is an imprint of Arcadia Publishing
Charleston, South Carolina

Printed in the United States of America

Library of Congress Control Number: 2012950061

For all general information, please contact Arcadia Publishing:
Telephone 843-853-2070
Fax 843-853-0044
E-mail sales@arcadiapublishing.com
For customer service and orders:
Toll-Free 1-888-313-2665

Visit us on the Internet at www.arcadiapublishing.com

Dedication
This book is dedicated to all the people who appear in these pages and make my hometown such an interesting place to live.

On the Cover: From left to right:
(TOP ROW) Joe Alpert with his grandchildren Steve and Audrey Berry (Courtesy of Nancy Mower; see page 42), actress Hattie McDaniel (Author's collection; see page 46), Col. William O. Collins (Local History Archive; see page 11), World War II pilot Courtlynn Hotchkiss (Local History Archive; see page 113), and renegade Jack Slade (Local History Archive; see page 34).
(MIDDLE ROW) Annie the railroad dog (Local History Archive; see page 97), nurse Clara Ray (Local History Archive; see page 61), Arapaho Chief Friday (Local History Archive; see page 14), flood survivors Ervin and Nancy Deal (Courtesy of Ervin Deal; see page 103), and a painting by cowboy Frank Miller (Local History Archive; see page 41).
(BOTTOM ROW) mezzo soprano Joy Davidson (Courtesy of Joy Davidson; see page 89), college professor Dr. Temple Grandin (Courtesy of Temple Grandin; see page 57), rodeo performer Shorty Creed (Local History Archive; see page 47), former mayor Nancy Gray (Courtesy of William Gray; see page 59), and released hostage Tom Sutherland (courtesy of Tom Sutherland; see page 37).

CONTENTS

ACKNOWLEDGMENTS

What a fine time I have had writing this book! I have met, in person, by e-mail, and in the pages of books and articles, a fascinating array of individuals, some who have peopled our past and some who are making history today. To all of them, I offer my profound gratitude. In my person-to-person interviews, I learned so much more than I could put in these pages; many expanded stories appear on my web page, www.authorbarbarafleming.com. Thanks to my daughter, Alison Day, for being my webmaster.

To Lesley Drayton, Museum of Discovery archivist, and her able assistant, Jayne Hansen, "thank you" hardly seems adequate. To Malcolm McNeill, friend, photographer, and scanner extraordinaire, goes the same.

A thank-you goes to everyone, far too many to list here, who provided me with images. Some stories and photographs came from afar; special thanks go to David Mattingly, John Mattingly, Ora Shay, Nancy Mower, and Joy Davidson. Many thanks to the Colorado State University Athletic Department.

Since the majority of the photographs in this book are from the Fort Collins Local History Archive, these are identified by file number only, in the event readers want to access them. Photographs taken by or from the collection of Malcolm McNeill are indicated by the symbol (MEM). All others are credited "courtesy of" the individual, business, or institution providing them.

Words are insufficient to describe how fortunate I feel to have grown up in this community, to have had the opportunity to write about it, and to make my home here now. It is a very special place, with very special people, and I am grateful that I can call it my home.

INTRODUCTION

From an isolated outpost in the real Wild West, complete with cattle rustling, hangings, and shootouts, to a thriving city of 150,000 residents boasting a sizable university and several industries, the story of Fort Collins, Colorado, has unfolded with a stage-worthy cast of characters: stalwart pioneers, stubborn believers, forward-thinking leaders, and others with their feet firmly planted in the status quo. Creators, innovators, rogues, heroes, risk-takers, newsmakers, and entrepreneurs, among many others, have populated our story over the years.

With the nation, Fort Collins experienced the dawn of the automobile age, the impact of two world wars, the heady optimism of the 1920s, and the drought and the Depression of the 1930s. With the nation, our town lived through the prosperous 1950s, in which World War II veterans returned to give the town a hefty boost in population; the restlessness of the 1960s and 1970s, including marches, demonstrations, and a devastating fire on the college campus; and the emergence of the computer age. By the turn of the new century, the town had become a mid-size city with all the attendant rewards and complications. The computer age, rapidly becoming the digital age, had come full flower here, and the small agricultural college transitioned to a major university. Though it will always be a part of this land-grant college, agriculture has taken a back seat to other academic disciplines. What was simply "downtown" to this author, growing up here, became part of Old Town as the boundaries of the city expanded.

Old Town's downtown deteriorated for several decades until the city became interested in its heritage and embarked on a major renovation project. Now, downtown bustles with shoppers, theatergoers, and partakers of nightlife.

Prohibition came to the country in the 1920s; it came to Fort Collins, a town with an abundance of churches, much earlier. From the 1890s until the 1960s, our town was dry. Residents had to go beyond the city limits to get liquor, and bootlegging flourished here. With growth came sophistication, and under the leadership of a dedicated group of citizens, prohibition ended after seven decades. Today, spirits are easily obtainable.

In the 1880s, Fort Collins sought to prove that it was more than a mere cow town by building an elegant hotel and an opera house. Culture came to town early in our history, with dramas, recitations, and musicales, and it has played a prominent role ever since. By the mid-20th century, community theater began to flourish, with several local groups forming. Thanks to the vision of a progressive group of local citizens, the old Lincoln Junior High School was transformed in the 1970s into the Lincoln Center for the Arts, featuring a large auditorium designed to host the symphony orchestra, an art gallery, a smaller stage, and meeting rooms. Our town supports an opera company and the Canyon Concert Ballet as well. Trimble Court Artisans, an art cooperative, offers local artists a venue for their work, along with other galleries. A parody group, The Mostlies, recently celebrated its 20th anniversary. In the early 21st century, residents approved funding for updating and enlarging the Lincoln Center, proving once again that Fort Collins is much more than a small cow town.

Like any place where people live, Fort Collins has not lived a life filled only with tea and roses. There have been tragedies, natural disasters, conflicts, and clashes. Crime comes to small towns just as it does to big cities. Some of those stories are told in the pages of this book.

People create history, shape the present, and forge the future. Throughout our history, our Western high-plains town has attracted a colorful array of people, many of whom the reader will meet in these pages.

An early settler depicted in Chapter One was an intrepid widow with several children who opened a lodging house near the fort and cast her first vote in her 90s, years later. Then, there was the Indian

chief whose faith in his Anglo friends turned out to be misplaced, and the carpenter-turned-architect whose structures still grace Old Town.

An Irish laundress who gained a title when she married a displaced Englishman; a scoundrel who, when he was drunk, thought nothing of terrifying everyone around him nor of the consequences for murder; an airman who was one of the first to take to the skies; and a lawyer who was the victim of Fort Collins's first drive-by shooting are among the lively cast of colorful characters whose stories are told in Chapter Two.

In Chapter Three, readers will meet the residents who have given back to the town through their leadership, their philanthropy, their sacrifice, or their dedication to the betterment of the community. Chapter Four introduces readers to some of those who have contributed to the cultural scene here, founding theaters or other performing arts groups and vigorously supporting the arts.

The last chapter explores ordinary lives that have taken extraordinary turns—authors, business owners, and humanitarians, among many others.

Within the confines of these pages, it is not possible to include everyone who has contributed to the story of Fort Collins. Many early pioneers have been recognized in other works. My goal was to present a cross-section of our unique history and culture, shining a light on some residents who may not be as well known, throughout our 150-year history, but who have been a notable part of the fabric of this city's life. All of the people included in this book have touched Fort Collins in some significant way. Some of their stories are well known—indeed, they are local legends—while other stories tell of quiet lives lived well, gracing the city with their skills, talents, and enthusiasms and creating legends. Some people have experienced times of drama or heartache; others have marked noteworthy achievements perhaps unknown to the general public. Each one is or was an individual to whom our town owes gratitude, and each one has been a part of making our story a rich and lively one.

CHAPTER ONE

Settling In

Although trappers and Native Americans were roaming the Poudre Valley earlier in the 19th century, the story of Fort Collins did not begin until an Army fort was established here in 1862, as part of the effort to contain the native population and protect settlers traveling West. The fort, a small, unfenced encampment, lasted until shortly after the end of the Civil War, when it was dismantled. A few discharged soldiers decided to stay, and other settlers joined them. By 1872, a planned community with platted streets was in place.

The eventful history of the town has attracted several authors who have told the story fully and well—here, the focus is on the people who came and began to tame the small settlement with its false-front buildings, wooden sidewalks, and muddy, horse-trampled byways. The new town was laid out at an angle to the first post-fort structures along the banks of the Poudre River.

The adventurers came—many more than are presented in these pages. To place them in their time and space, picture a compact community, its main street fading into the horizon only a short distance from its center, its commerce gradually attracting entrepreneurs, its people braving hordes of grasshoppers, drought, fierce blizzards, and myriad other challenges—but hanging on. This chapter introduces readers to some of those early visionary settlers, who were a hardy, determined bunch. Because of them, the town survived.

As with the remaining chapters, this one offers only a cross-section of legendary locals, chosen to give a broad view of our city's past and present.

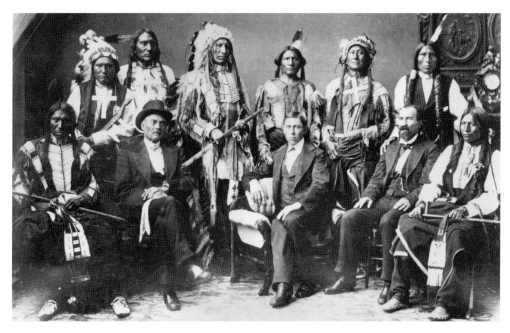

Antoine Janis, First Pioneer

What a beautiful sight Antoine Janis must have seen when he came to the Poudre Valley in 1844. Upon seeing unspoiled meadows, lush vegetation near the rushing river that teemed with fish, buffalo grazing, and evidence of other wildlife, he dubbed it "the loveliest spot on earth." From his early years, Janis had been interacting peaceably with Sioux tribes and, after a time, he married a Sioux woman. With his wife, First Elk Woman, and their family, he returned to the valley in 1858 to stake a claim. There, they lived and raised their children amid the turmoil of Western immigration and Indian wars, during which time two of his mixed-race sons, Pete and Willie, were murdered. By 1882, when the federal government had subdued Native American tribes all over the West, men who had homesteaded with their Sioux wives were told they had to divorce them in order to keep their land. The alternative was to spend their remaining time on the Pine Ridge Reservation in South Dakota. Many of these men chose to stay with their land and let their wives and families fend for themselves on the reservation—but not Janis. He chose the reservation, his wife, and his family. He lived out his life at Pine Ridge. In the photograph are, from left to right, (standing) He Dog, Little Wound, unidentified, Little Big Man, Young Man Afraid of His Horse, and Sword; (sitting) Yellow Bear, Janis (Yellow Hair All Messed Up), William Garnet, Joseph Merrivale, and Three Grizzly Bears. Janis died at the reservation in 1890. In 1910, the Daughters of the American Revolution placed this plaque recognizing the name of the Cache la Poudre River, "Hide the Powder," most likely given by French trappers. (Above, H06949; below, H00826.)

Col. William O. Collins, Soldier

An attorney who enlisted at the outbreak of the Civil War, William O. Collins gathered a regiment and was sent West to command an Army post, Fort Laramie, in Wyoming. Troops from his 11th Ohio Cavalry were sent from the fort to Camp Collins, named after the popular leader. After leaving the Army, Collins retired to his home in Hillsboro, Ohio, where he died in 1880. (H01513.)

Caspar Collins, Hero

In July 1865, young Caspar Collins, the colonel's son, was stationed at Fort Collins. While on patrol with some cavalry troops in Wyoming (near present-day Casper), he saw a wagon under attack. The 20-year-old, impulsive, inexperienced soldier led a small cavalry charge on a rescue mission. Seeing one of his comrades wounded, Caspar rode into the melee. He was surrounded by Indians and killed. (H01207.)

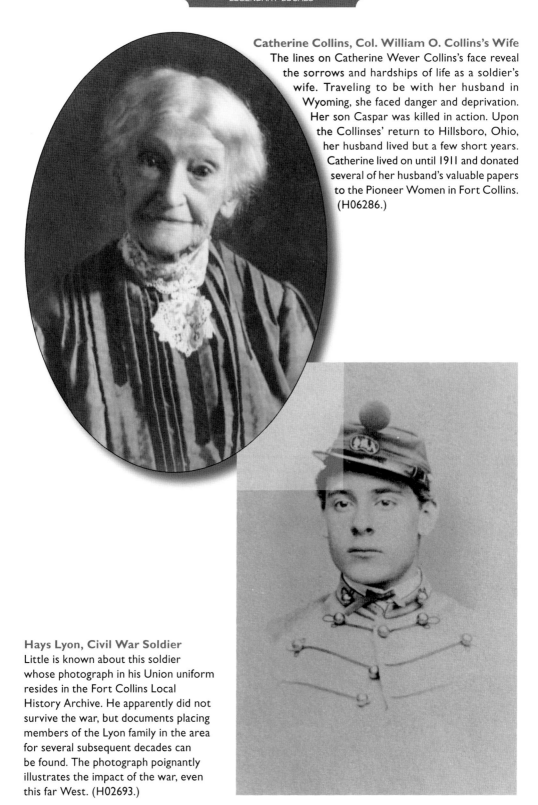

Catherine Collins, Col. William O. Collins's Wife
The lines on Catherine Wever Collins's face reveal the sorrows and hardships of life as a soldier's wife. Traveling to be with her husband in Wyoming, she faced danger and deprivation. Her son Caspar was killed in action. Upon the Collinses' return to Hillsboro, Ohio, her husband lived but a few short years. Catherine lived on until 1911 and donated several of her husband's valuable papers to the Pioneer Women in Fort Collins. (H06286.)

Hays Lyon, Civil War Soldier
Little is known about this soldier whose photograph in his Union uniform resides in the Fort Collins Local History Archive. He apparently did not survive the war, but documents placing members of the Lyon family in the area for several subsequent decades can be found. The photograph poignantly illustrates the impact of the war, even this far West. (H02693.)

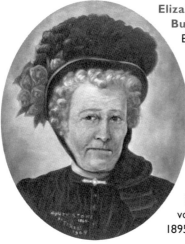

Elizabeth Stone, Businesswoman

Elizabeth "Aunty" Stone, one of the first Anglo women in Fort Collins, came with her husband, Lewis, to build a boardinghouse at the Army fort in 1864. Unfortunately, Lewis died, but the undaunted Elizabeth ran a hotel and dining hall and later invested in a mill. A fixture in the community and a strong advocate for temperance, she lived into her 90s, casting her first vote shortly before her death in 1895. (H09958.)

Lindell Mills, Centenarian

After a shaky start, complicated by the loss of their money in a mugging, Elizabeth Stone and her partner, Henry Clay Peterson, completed their gristmill in 1869. The building, the tallest in town then, was located near the Poudre River. Surviving fires, changing ownership, financial setbacks, and name changes, the business on Linden Street, now Ranchway Feeds, is the longest continuous enterprise in Fort Collins. (H06612.)

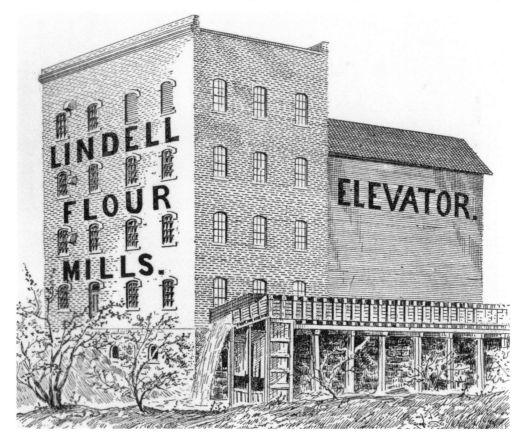

Chief Friday, Interpreter
Arapahos inhabited this area long before settlers came. Most memorable of them was Friday Fitzpatrick, who had feet in two worlds. Found as a boy by Thomas Fitzpatrick, he was educated in the white way but returned to his tribe as a young man. He traveled to Washington, DC, to meet the president and was a respected tribal chief and trusted interpreter. His people were ultimately consigned to a reservation in Wyoming. (M05883.)

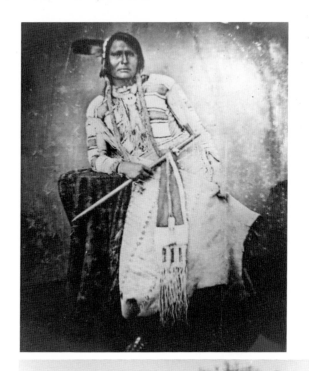

Arapaho Council Tree
Under this 100-foot-tall cottonwood tree (native to the area), Arapaho tribes would gather for tribal councils and sometimes place their dead in the branches. The tree was located near the Poudre River on land that, at the time, belonged to Robert Strauss. The area had long been a favorite camping ground for native tribes. The tree was destroyed in a fire in 1938. (H05403.)

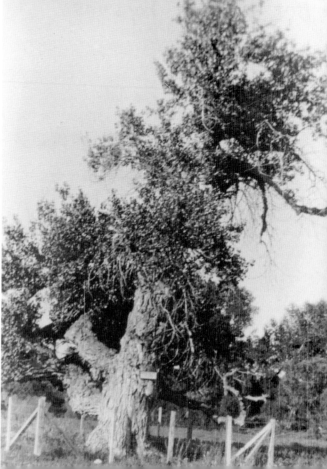

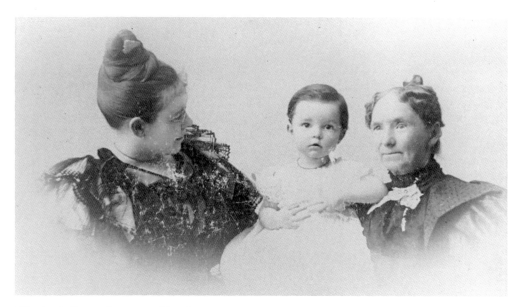

Elizabeth Keays Stratton, Teacher

Young, unattached women were scarce on the frontier. Widowed Elizabeth Keays, pictured on the right holding her grandson Keith with her daughter, Lerah McHugh, traveled West with her son Willie in 1866 and was courted by Harris Stratton. The couple married in the first-known wedding ceremony between two Anglos in Larimer County. After starting the county's first school, the new bride turned over her school to an unmarried successor. (H02044.)

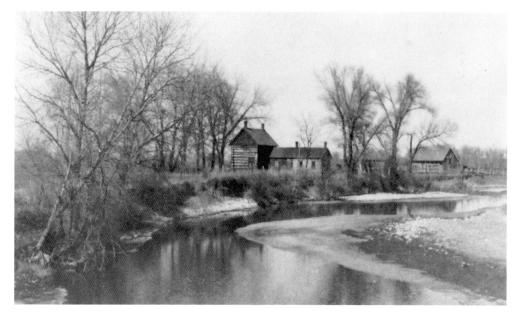

Robert Strauss Cabin

Robert Strauss came to the Poudre Valley in 1864, making him one of the earliest settlers. He built his cabin near what is now Timnath. That same year, he survived a flood. But when another flood came in 1904, the feeble old man could not escape. He was found in the morning clinging to a fence, barely alive. He lived only a few more days; years later, the cabin was consumed by fire. (H01857.)

Chester Giddings, Farmer
In his history, Ansel Watrous describes farmer E. Chester Giddings as having "good judgment and wise foresight." Giddings came to Fort Collins in 1883 with his parents. In 1888, he married Agnes Mason. Giddings began on a rented farm and made a success of it, which was sufficient enough for him to purchase a winter home for the family on West Mountain Avenue. He was also a volunteer fireman. (H01561G.)

Agnes Mason Giddings, Pioneer
Agnes Mason was known as the first Anglo child born in Fort Collins. She was the daughter of Augustine and Charlotte Mason and came into the world October 31, 1867, in Aunty Stone's cabin. After marriage to Chester Giddings, she was involved in Masonic temple activities and several social and literary clubs; according to journalist Ansel Watrous, she was a "woman of culture and refinement." (H01560.)

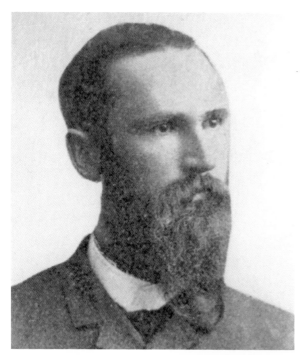

Dr. Charles Miller, Physician
Dr. Charles P. Miller wore several hats. He came to Fort Collins in 1878, age 25, and lost his first wife and their daughter in a diphtheria epidemic. In the 1870s, he was county health officer and coroner, pronouncing judgment on a murderer who was lynched in 1878. He married Nora Rice, who also became a physician after his early death in 1901. She practiced here for several years. (H06885m.)

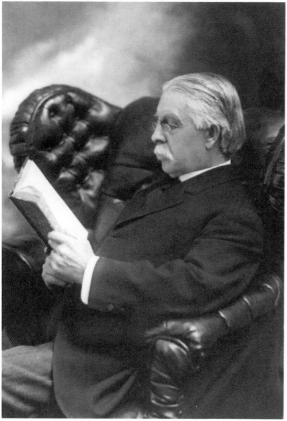

Franklin Avery, Founding Father
If anyone is a founding father, Franklin Avery is one. Although no street in town bears his name, his influence threads through the history of Fort Collins; he laid out the city's streets in 1872, founded a bank (now First National), served on the city council, and promoted a progressive water system. The gracious house he built on Mountain Avenue, carefully preserved, stands as a monument to his many contributions. (H11348.)

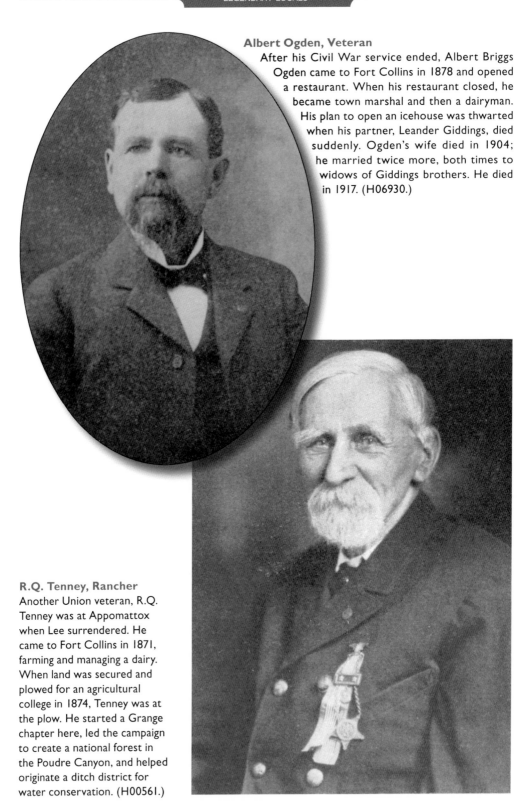

Albert Ogden, Veteran
After his Civil War service ended, Albert Briggs Ogden came to Fort Collins in 1878 and opened a restaurant. When his restaurant closed, he became town marshal and then a dairyman. His plan to open an icehouse was thwarted when his partner, Leander Giddings, died suddenly. Ogden's wife died in 1904; he married twice more, both times to widows of Giddings brothers. He died in 1917. (H06930.)

R.Q. Tenney, Rancher
Another Union veteran, R.Q. Tenney was at Appomattox when Lee surrendered. He came to Fort Collins in 1871, farming and managing a dairy. When land was secured and plowed for an agricultural college in 1874, Tenney was at the plow. He started a Grange chapter here, led the campaign to create a national forest in the Poudre Canyon, and helped originate a ditch district for water conservation. (H00561.)

Franklin Moore, Missionary

Franklin Moore did not set out to be a minister. When he came to Fort Collins with his wife, Martha, in 1878, he first taught school and then tried unsuccessfully to farm. In 1892, he became pastor of the Hillsboro Presbyterian Church. He also served parishioners in Bellevue, Livermore, and Virginia Dale, traveling from town to town on horseback. Later, he became a missionary to residents in several towns around the area. (H01575.)

Walter Taft, Farmer

A distant relative of Pres. William H. Taft, Walter Taft came with his brother, Louis, to the Poudre Valley in 1872. The brothers grew and sold hay, ranched cattle, and built a home on the road bearing their name, Taft Hill, northwest of town. Walter was involved with the Pioneer Association, serving as its president, and prospered as a farmer. (H01477T.)

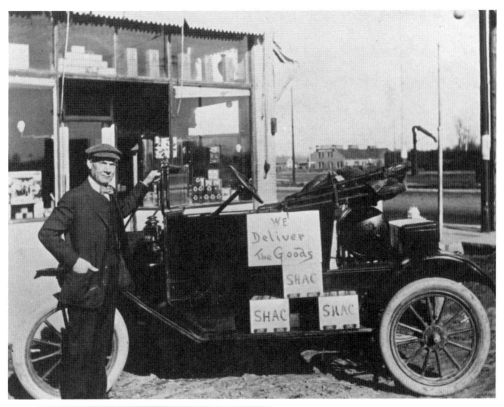

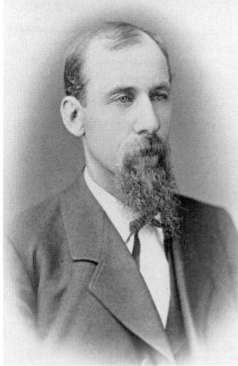

Frank And William Stover, Businessmen

Frank Stover and his brother, William, were both successful businessmen in Fort Collins. William, who came West in 1860, arrived in Fort Collins in 1870, where he and John Mathews established a grocery store in Old Grout. Frank came in 1874 and bought City Drug, which is still in business despite fires and other setbacks through the decades. The photograph shows him in front of his drugstore, which he sold in 1918. Frank served two terms as county treasurer. William was a founder of the Poudre Valley National Bank, which has become Wells Fargo bank. William represented Larimer County at the constitutional convention following which Colorado became a state in 1876. He married three times, having been widowed twice, and died in 1908. (Above, H07854; left, H01974.)

Pierre Dastarac, Painter

Though little is known about Pierre Dastarac's personal life, he left a priceless legacy—a 19th-century bird's-eye view of Fort Collins. Today, two views survive, with one created in 1881 and one in 1884; the latter is shown here. He may also have painted some of the "ghost signs" in downtown Fort Collins. Seated at left, he is seen with other unidentified individuals in front of what is believed to be his Fort Collins home. The bird's-eye view, a popular art form at the time, shows College Avenue, the original town parallel to the river, and the new town laid out at compass points, angled to the old settlement. A closer view shows drawings of several significant buildings, among them the Tedmon Hotel, Lindell Mills, and some private homes. (Above, H08131; below, H00044.)

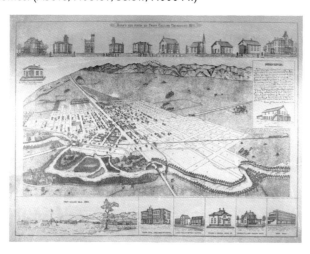

E.E. Edwards, College President
The first president of the new Colorado Agricultural College, founded in 1874 under the Morrill Act, was Elijah E. Edwards. A Civil War chaplain, he came to the college in 1879 and welcomed a first class of five students. Each day began with chapel services. Two years later, Edwards clashed with the board of agriculture over dormitory management and was asked to leave. (S01450.)

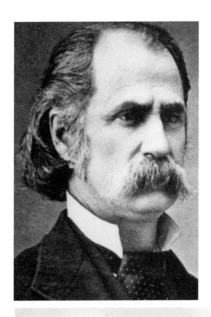

Elizabeth Coy Lawrence, Student
One member of the college's first graduating class was Elizabeth Coy, shown here after an apparently tiring climb. Coy took a class from James Lawrence, a professor in the Department of Mechanics and Drawing, and they married in 1890. James Lawrence served as acting president of the college in 18? and was dean of the faculty from 1906 to 1912. As a student, Elizabeth Coy Lawrence won an oratorical competition. (H08575.)

B.F. Hottel, Industrial Pioneer Ansel Watrous gave Benjamin Hottel the above distinction because Hottel was willing to take investment risks in a new settlement. He came to Fort Collins in 1877 and partnered with Joseph Mason in the Lindell Mills, becoming sole owner after Mason's death. Hottel was instrumental in bringing the sugar beet factory to town in the early 1900s and later served as president of Poudre Valley National Bank. The luxurious home he built on South College Avenue (where Ace Hardware is now), featuring chandeliers and porticos and other architectural marvels, was dismantled in the 1970s and replaced by a J.C. Penney store. Part of one room is shown here. (Left, H02956; below, H19015.)

Bee Family, Farmers
A Colorado Centennial farm, the Bee Family Farm near Wellington was established in 1882 by John and Fanny Bee, who came West to alleviate John's asthma. The history of the farm parallels the history of Western agriculture. Today, it is a working museum and research farm owned and operated by Colorado State University, with 10 acres retained by the family. Shown are John and Fanny Bee with their children, from left to right, Arleigh, Arthur, and Emma. (Courtesy of Liz Harrison.)

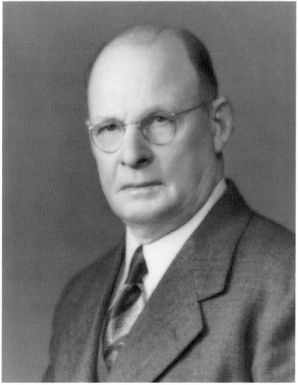

James Coutts, Agriculturalist
At age 15, James Coutts fought in the Boer War. In 1906, he came from Scotland to Fort Collins to farm (where the Fort Collins Senior Center is now). Coutts was chair of the state Farm Home Administration Agricultural Stabilization Conservation Office and vice president of the Colorado State Association of Soil Conservation Farm Bureau. The Kiwanis Club named him "Agricultural Leader of the Year," and he received the soil conservation award in 1965. (Courtesy of Margaret Fillmore.)

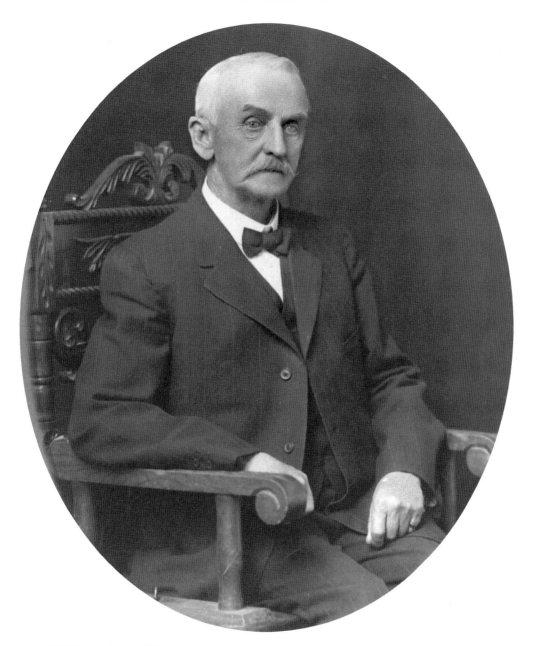

Ansel Watrous, Journalist
No historical record of Fort Collins would be complete without including Ansel Watrous, whose *History of Larimer County* is a priceless resource for anyone interested in the town's past. He came to Fort Collins in 1877, perhaps because his uncle, William Watrous, was already here. He started a newspaper, the *Fort Collins Courier*. Though he had to ship the paper to Chicago for printing in the beginning, he persisted and made a success of it. Watrous later edited the *Fort Collins Morning Express*. (Eventually, the two newspapers merged to become the *Express Courier*, which became the Fort Collins *Coloradoan*.) After years of work on his book, he published it in 1911 to less than rave reviews. In fact, sales were so dismal that he burned most of the remaining copies. Childless, Watrous lived into his 90s—but not long enough to know that his book had been revived and is now a historical treasure. (H00653.)

Jacob Welch, Merchant

Coming to Fort Collins in 1873 when it was said by Watrous to be a "frontier hamlet," Jacob Welch opened a store at College and Mountain Avenues. The Welch Block housed a store and hotel. In 1880, fire destroyed the structure, killing two people, but that same year, Welch rebuilt—making his the first three-story building in town. It also burned, but by then, Fort Collins had a volunteer fire department. Welch died in 1888. (H06889.)

John Zimmerman, Mountaineer

Below, from left to right, John Zimmerman, unidentified guest, Eda Zimmerman, John McNabb, and Agnes Zimmerman are enjoying an evening at the Keystone Hotel in Poudre Canyon, a prime resort in the 1880s. Born in Switzerland, Zimmerman came to Colorado in 1880 and built the resort log by log; then he built a brick hotel. After his death in 1919, Eda and Agnes tried to keep the business going, but when Eda died, Agnes gave up. The resort is gone. (H00056.)

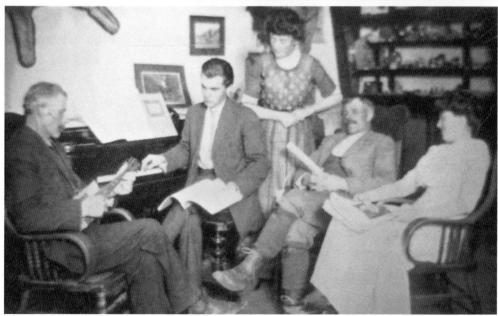

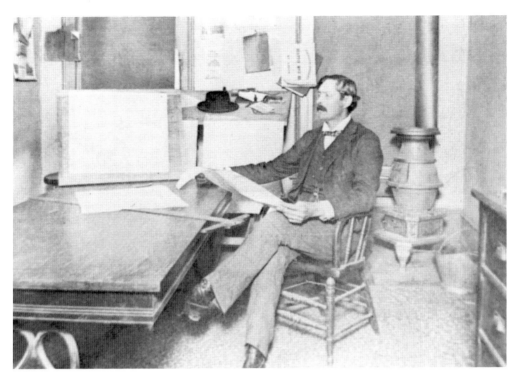

Montezuma Fuller, Architect

Almost anywhere in downtown Fort Collins, buildings designed by architect Montezuma Fuller, including private homes, churches, office buildings, and schools, still stand. Arriving here in 1880 at 22, untrained in architecture but gifted with an eye for design, he worked as a carpenter until asked to design a church, soon establishing himself as an architect. His second wife was a widow whose house he had designed. He died in 1925. One of his most prominent designs is the Avery Block at the northeast corner of College and Mountain Avenues; it was constructed in 1897 to serve the purpose of a bank. The pink sandstone building, created with stone from the quarry at Stout west of Fort Collins (now under Horsetooth Reservoir), is still in use by local businesses. (Above, H12482; below, H12482.)

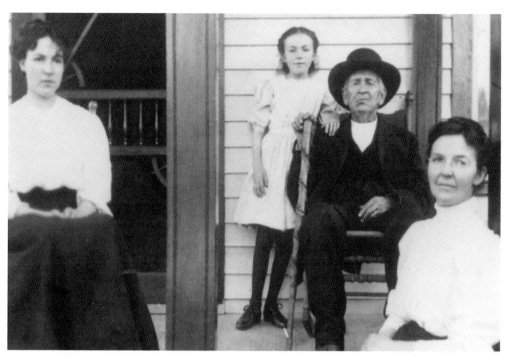

Ben Whedbee, Mayor
Fort Collins's first mayor, Ben Whedbee, shown here on his front porch with, from left to right, Grace, Marion, and Elizabeth Travis, was an early settler here, arriving in 1871. He opened the first drugstore in town and then established a mercantile. After retiring, he served the town not only as mayor but also as county treasurer and was a member of the State Board of Agriculture, the governing body of the college. (H08981.)

Stewart Case, Hotelier
After Stewart Case came to the area in 1886, he taught at several schools for about a decade. In 1901, he was appointed deputy county assessor and was subsequently elected assessor. Case and his wife, Lillian, then began operating the Forks Hotel in Livermore, on US 287. Built in 1874, the building has since been rebuilt following a 1999 fire. Case descendants still live in the area. (H00191c.)

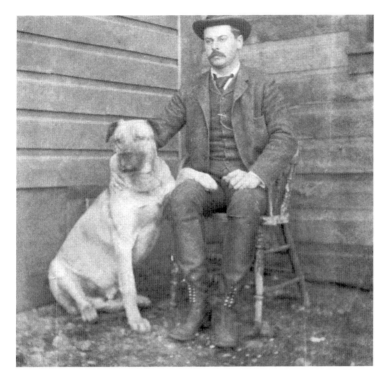

Rudolph Booream, Supervisor
A consortium of local businessmen combined resources to bring a sugar beet factory to Fort Collins in 1904. Later that year, the Great Western Sugar Beet Company purchased it. The first supervisor was Rudolph Booream, shown here with his dog. Booream left the post in 1911, not long after his wife, Mary, was killed in an automobile accident. Going 30 miles per hour, she lost control of her car; it overturned into a ditch. (MEM.)

Sugar Beet Plant
The arrival of a sugar beet industry in Fort Collins heralded a new period of growth. Peter Anderson developed a housing community across from the factory, which was on the north end of town near the railroad tracks, and the workers began to arrive—first Germans from Russia and later Mexicans. The plant, shown here during the early years, operated until the 1950s. (H05992.)

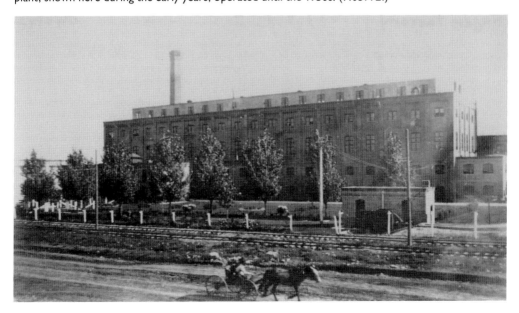

Will and John Lyon, Immigrants
Turn-of-the-century finery is shown off in this photograph of Will Lyon (left) and his brother, John. John Lyon drove a stage for the Overland Stage Company for several years before coming to Laporte in 1867, where he worked as a store clerk. He later started farming near Laporte. The brothers' sister, Mary, came West with them and married Fort Collins pioneer Henry Peterson. (H02695.)

Mrs. T. Wilkins, Columbian Clubber
An active member of the Columbian Club, a woman's club of the time, the fashionable Emma Wilkins often made presentations and engaged in debate. She also started a subscription library in her husband's photography studio. Patrons paid a fee to borrow books. Fort Collins did not get a public library building until 1912, although a free library was established around the turn of the century. (H06878.)

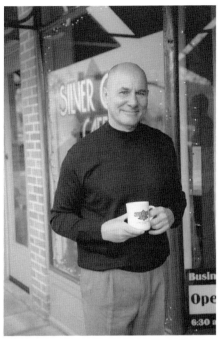

John Arnolfo, Restaurateur
Owner John Arnolfo stands in front of his restaurant, the Silver Grill, in Old Town. Arnolfo has owned the restaurant, the longest continuing restaurant in Colorado, for 33 years. He came to Fort Collins to attend college and, like many another, decided to stay. He has expanded the restaurant and changed the menu to accommodate modern tastes, but the popular eating establishment has a long-standing, loyal clientele. (Photograph by Lisa Wilson; courtesy of John Arnolfo.)

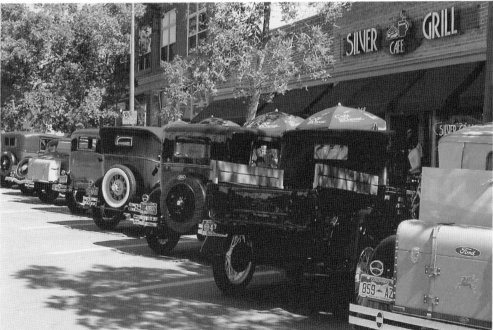

Silver Grill Restaurant
This Lisa Wilson photograph of the Silver Grill features several period automobiles parked in front. Beginning in 1912 as the UNEEDA LUNCH diner, it opened a few doors down from city hall on Walnut Street. It moved to its current location, 218 Walnut Street, in 1933 when purchased by Pete Widger, who changed the name to the Silver Grill. Some features of the original diner remain today. (Courtesy of John Arnolfo.)

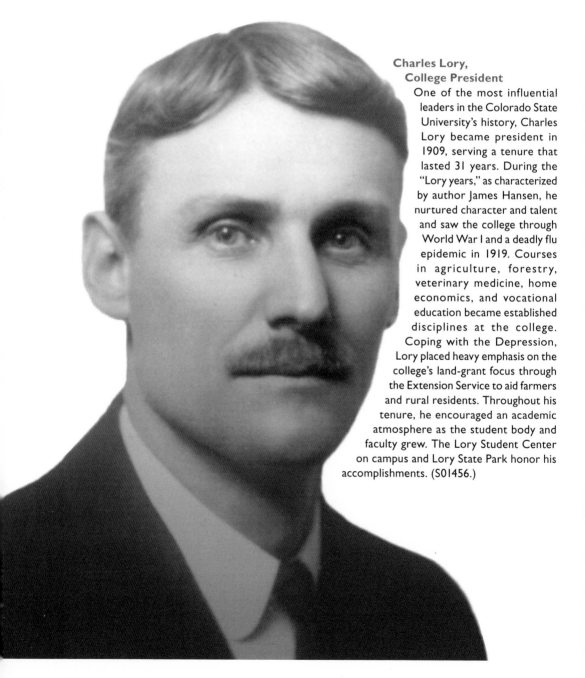

Charles Lory,
College President
One of the most influential leaders in the Colorado State University's history, Charles Lory became president in 1909, serving a tenure that lasted 31 years. During the "Lory years," as characterized by author James Hansen, he nurtured character and talent and saw the college through World War I and a deadly flu epidemic in 1919. Courses in agriculture, forestry, veterinary medicine, home economics, and vocational education became established disciplines at the college. Coping with the Depression, Lory placed heavy emphasis on the college's land-grant focus through the Extension Service to aid farmers and rural residents. Throughout his tenure, he encouraged an academic atmosphere as the student body and faculty grew. The Lory Student Center on campus and Lory State Park honor his accomplishments. (S01456.)

CHAPTER TWO

Living a Colorful Life

Many a unique and memorable character has enlivened the story of Fort Collins. Some were rogues; some were rugged frontiersmen. Less restricted in the West than in the settled East and Midwest, frontier women were bold, even daring to equate their rights with those of men. (Wyoming was the first state to grant women the right to vote; Colorado was the second.) Some of these individuals were heroes. Others were entrepreneurs, advocates, or athletes. They racked up firsts, attracted notice, and, in some cases, achieved a degree of fame. Whatever their accomplishments, they remain part of the fabric of Fort Collins's history. For some, their stories are still unfolding. The story would be far less colorful without them.

Jack Slade, Renegade
Hanging from his watch chain for all to see was a pair of ears, which had once belonged to another man. The Overland Stagecoach Company considered Jack Slade one of its best drivers, but when Slade was in his cups, he tore up establishments and sometimes killed people. Slade's fatal flaw finally got him hanged by vigilantes in Montana in 1864. Never to know that his wife, Virginia, was racing desperately to save him, Slade pleaded for his life. Virginia was too late. (H07404.)

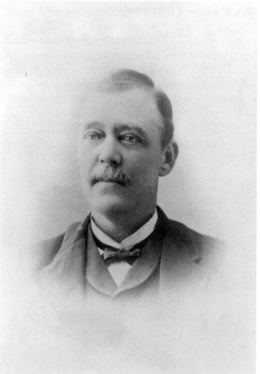

Arthur Patterson, Indian Fighter
After he scalped an Indian during a skirmish in Wyoming in 1870, Arthur "Billie" Patterson considered himself an Indian fighter. He had also fought in the Civil War battle of Glorieta Pass and traveled with Buffalo Bill Cody. But when the time came to settle down, he married and started a business in Fort Collins. His quiet life ended in 1892, at only 48. Cody later prompted the college to honor its land donors, including his lifelong pal. (H00584.)

Marie Lafitte, Free Spirit

Marie Lafitte arrived here around 1900. She earned her living by means of the "world's oldest profession" and by selling liquor—in a dry town. Arrested repeatedly and sued by a vindictive attorney, she fought back until a savage beating by said attorney laid her low. At her peak of success, Lafitte owned property on Jefferson Street, which would have looked much like this 1920s photograph. Her spirit finally broken, she died in 1914 in the county poorhouse. (H14877.)

Catherine Moon, Lady

Catherine Lawder came to Colorado from Ireland and started out as a laundress. She married but quickly divorced when she met Lord Cecil Moon, an English "remittance man." Even though they divorced (she paid him alimony), she retained her title of Lady Moon, often spoke of meeting Queen Victoria, and managed a large, thriving ranch for years. Stories about her abound. She died in 1926. (H01504.)

Fancher Sarchet, Lawyer
Shakespeare said, "Kill all the lawyers."
On September 9, 1927, Clyde Barelson
tried to kill just one. He pulled up
beside lawyer Fancher Sarchet's car
and shot him in the face. Sarchet
lost his left eye but hunted down the
perpetrator and the man who had
hired him, J.J. Verstraten, with whom
Sarchet had tangled in court. The long,
complicated story is told in Sarchet's
book, *Murder and Mirth*. (H10067.)

Phyllis Mattingly, Welcome Lady
Though she had other careers and
avocations, Phyllis Mattingly was
perhaps best known in Fort Collins as
the "welcome lady." After coming here
with her husband, John, in 1949, she
started a business, bringing newcomers
gifts, coupons, and information
about the town. She also had a local
radio show, *Coffee with Colleen*. She
continued to be active, including
such activities as dancing, writing,
and offering expert graphoanalysis,
until her death in 2000. (Courtesy of
David Mattingly.)

Stuart VanMeveren, Attorney

A teaching position at the university brought Stuart VanMeveren to Fort Collins in 1967. He soon left that job to open a law practice. He ran for district attorney in 1972, a job he held for 32 years. Now retired, VanMeveren recalls one trial during which he had to wear a bulletproof vest due to the international implications. He saw the beginnings of the state public defender system and was involved in juvenile justice. (Photograph by Skillman Photography, courtesy of Stuart VanMeveren.)

Tom Sutherland, Freed Hostage

For six and a half years, from 1985 to 1991, yellow ribbons festooned trees all around Fort Collins, reminding residents of university professor Tom Sutherland, who was being held captive in Lebanon. Sutherland, a native of Scotland, had gone to American University in Beirut for a three-year term as dean of agriculture. At home, his wife, Jean, explored diplomatic channels to secure his release. When that came, the whole town celebrated his return. (Courtesy of Tom Sutherland.)

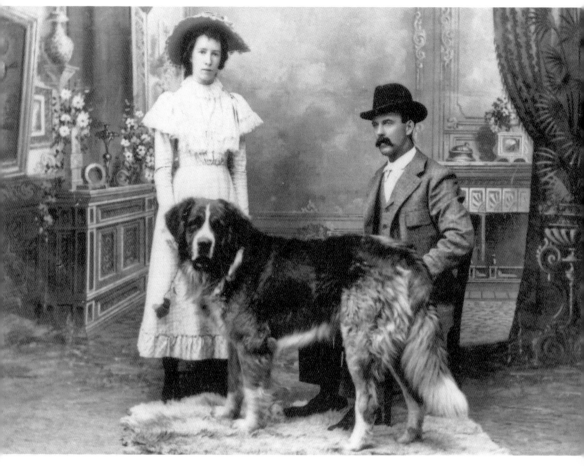

William Avery, Victim

Did Mary Avery kill her husband, William? William is shown here with his niece, Louise Avery. When he sickened and died in 1890 and his wife unwisely left town right after her husband's death with another man, Frank Millington (whom she soon married), authorities charged Mary Avery Millington with murder. William Avery had accumulated a sizeable fortune, which did not look good for the accused. In 1891, during a sensational trial held in Denver because of problems empowering an impartial jury here, the widowed woman maintained her innocence. The prosecutor contended that she had poisoned her husband so she could be with her lover, who had been seen entering and leaving the Avery home when Mr. Avery was not present. The prolonged trial included impassioned testimony from the Averys' daughter, Pearl, who pleaded touchingly on her mother's behalf. Given medical knowledge at the time, the jury's verdict of not guilty may have been the correct one. (H01178B.)

Guillame LaJeunuesse, Priest
The Rev. Guillame LaJeunuesse arrived in 1899 to lead the Catholic congregation here. The priest engineered the purchase of land at the northwest corner of Howes Street and Mountain Avenue; the new building, St. Joseph's Catholic Church, was dedicated in 1901. LaJeunuesse then went on to oversee construction of the Antlers Hotel, a rectory next to the church, and the building of St. Joseph's Parochial School, shown here. He stayed at the parish until his death in 1937. (Ha1140.)

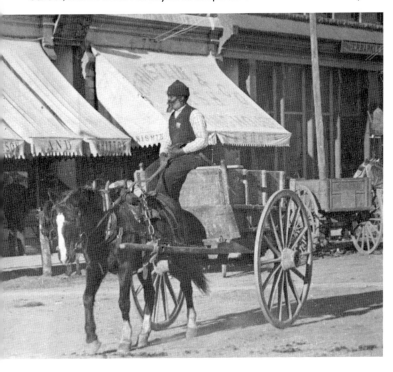

Charlie Clay, Free Man
Charlie Clay bought his freedom and came West in 1860. When war broke out, he joined the 11th Ohio. Clay survived the onslaught that killed Caspar Collins in 1865. When his cooking prowess was discovered, he stayed around the area and cooked—he even prepared a meal for Gens. Ulysses S. Grant and Tecumseh Sherman after the war. Clay eventually became the city trash collector and could often be seen around town in his wagon. (H00016.)

J.D. Forney, Industrialist

J.D. Forney left two legacies—Forney Industries on Laporte Avenue and the Forney Museum. Forney Industries has been in business since 1931 when Forney invented an instant-heat soldering iron that was successful enough to generate an industry. The business began downtown, but Forney soon moved out of the city limits. During the Depression, Forney's salesmen sometimes traded their products for eggs or livestock, but with the onset of World War II, the company expanded to meet the needs. In 1949, a fire broke out. The fire department came but could not fight the fire outside city limits, so they left the hoses. Forney had become prosperous enough that he could indulge his passion for old cars; he is shown here in one of his cars with his wife, Rachel. He opened a small museum here. The museum, still in operation, outgrew the local space and moved to Denver, where it houses not only vintage cars but also railroad cars and bicycles. (Courtesy of Jack Forney.)

Frank Miller, Cowboy and Painter
By 1900, Frank Miller, an admirer of Buffalo Bill Cody, had his own Wild West show. He was known for his ability to shoot with great accuracy standing on a moving horse. He owned a dude ranch, Trail's End, until going bankrupt in 1939. Miller, who was born here, moved into the Linden Hotel, where he spent his time painting and regaling anyone who would listen with his tales of adventure. This vivid painting of a cowboy on a horse is one of many Miller paintings held by the Fort Collins Museum of Discovery. Miller, shown in the photograph at left on the left with Capt. A.H. Hardy and Madeline Hardy, relived his adventurous early life as a cowboy through his paintings. (Left, H06858; below, H07529.)

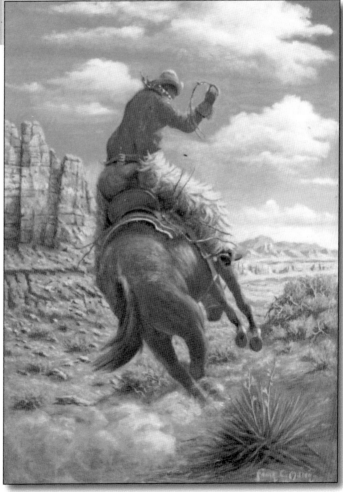

41

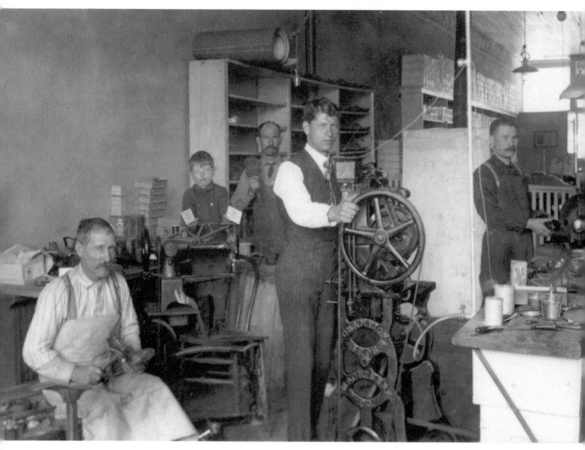

Joe Alpert, Cobbler

After seeing his grandparents killed before his eyes, young Joe Alpert fled Russia with his parents during a pogrom in 1885; his mother used silver spoons sewn into her clothes to sustain them during the journey and in America. In need of a dry climate because of asthma, he came to Colorado as a young married man and chose Fort Collins as the family's home because there were no saloons, the sugar beet factory held a promise of employment, and there was a college for his children's education. Joe, his wife, Fanny, and their children, Herbert, Ethel, and Helen, were among the first Jewish settlers in Fort Collins. The photograph shows Alpert (center) in his shoe repair shop, surrounded by employees, in the Alpert Building on College Avenue. When his house caught fire, he crawled through the flames to rescue his youngest child. At 62, he had a heart attack; medical wisdom at the time decided his legs needed to come off. Fitted with wooden legs, he drove a customized car and conducted his real estate business from a wheelchair. (Courtesy of Nancy Mower.)

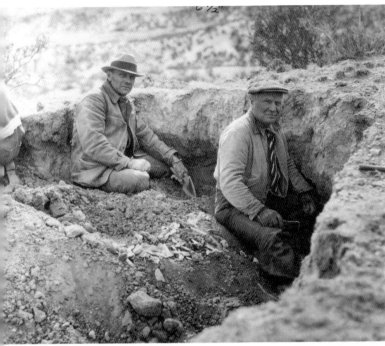

The Coffin Brothers, Excavators In 1924, Claude and A. Lynn Coffin were digging at a site north of Fort Collins, now part of the Soapstone Natural Area, when they discovered bones and artifacts indicating past inhabitants. The discovery at the Lindenmeier site yielded evidence of Folsom man's presence about 12,000 years ago. Judge Claude Coffin and his brother, Maj. Roy Coffin (right), are shown here digging at the site. (MEM.)

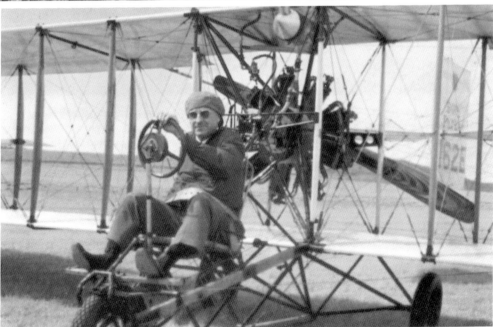

Billy Parker, Flying Ace
By 1912, powered flight was well established but highly experimental. Nonetheless, Fort Collins native Billy Parker was determined. He built a plane with lumber, wire, cloth, and a rotary engine, went to a nearby field, and took off into the air. Thus began his love affair with flight. He began barnstorming, flew in combat during World War I, worked as a test pilot after the war, and was employed by Phillips Petroleum's aviation division. He died in 1981, age 82. (MEM.)

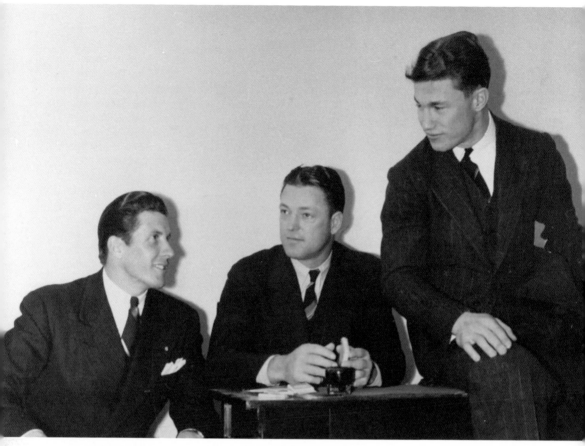

Glenn Morris, Athlete
Glenn Morris (center), shown here with Byron White and Dutch Clark (right), stunned the world when he won the decathlon at the 1936 Berlin Olympic Games. A graduate of Colorado A&M College, he trained for months in preparation for the event. After the Olympics, he briefly became an actor, playing Tarzan, and had a radio show. He tried professional football, too. Nothing worked out for him. Badly wounded during World War II, he died in obscurity in 1974. The university field house is now named for him. The other two men in the photograph, Byron White and Dutch Clark, were also outstanding athletes. A Colorado native, Clark played and coached professional football in the 1930s and 1940s. White, who was born in Fort Collins, attended the University of Colorado and played football, where he was known as "Whizzer White" for his speed. (H05058.)

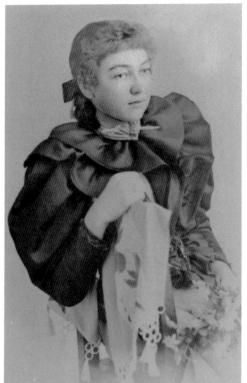

Mildred McAnnelly, Teacher

Though she was small and short, young Mildred Goldsborough began teaching at age 16. In 1894, teaching was one of the few professions open to women. She gained control of lads bigger than she by locking up their lunch pails. She taught for 10 years until she married Emmet McAnnelly. After his death, she began teaching again, at age 49, and taught or substituted for 40 years. She died in 1982, aged 104. (H07854.)

Roy Green, College President

Roy Green had not been president long on September 30, 1946, when he went to the Brown Palace Hotel in Denver to meet a new faculty member, veterinarian Dr. Harold Mullen. While Green, Mullen, and some other faculty members dined, a former Marine named Ronald Smith charged into the room waving a gun. He fired wildly. The shot hit President Green (standing in his ceremonial gown, center, in this photograph) in the shoulder. He survived, but his presidency was short-lived. (H00149A.)

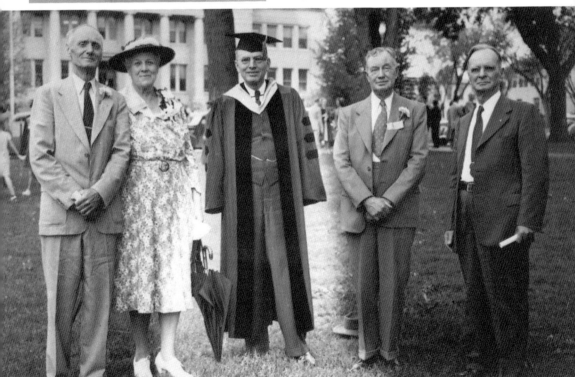

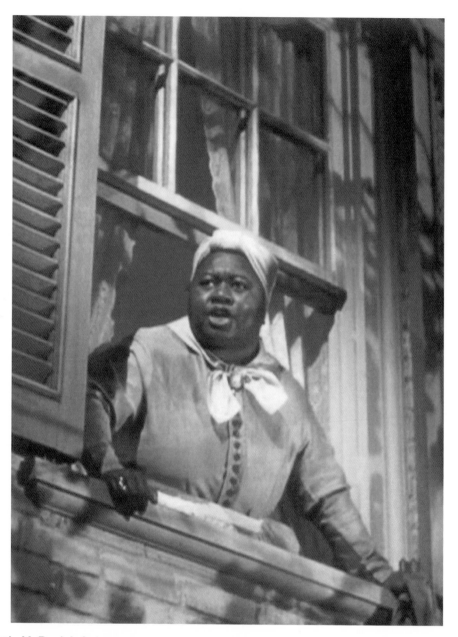

Hattie McDaniel, Actor

Hattie McDaniel, shown here in a scene from *Gone with the Wind*, lived in Fort Collins and attended Franklin School. Born in Kansas in 1895, she was the first African American to win an Oscar—or even to be nominated—when she received her accolade as best supporting actress in 1940 for the house slave role. McDaniel had roles in hundreds of films, including *Showboat* and *The Little Colonel* with Shirley Temple. She also sang, wrote songs, worked at times as a maid to support herself, and appeared on stage in comic roles. She was the first African American to be on radio. She died in 1952, aged 57. McDaniel was not allowed to attend the premier of *Gone with the Wind* in segregated Atlanta, and on the night she received her Oscar in Hollywood, she and her companion were seated at a separate table, away from the other members of the cast. (Author's collection.)

Shorty Creed, Bulldogger

During the 1930s and 1940s and beyond as long as he could, Loyce "Shorty" Creed was a rodeo cowboy who racked up trophies in competitions. He roped cows, rode broncos, and brought down bulls with the best of them, traveling the world and surviving more than one broken bone. After retirement, he and his wife, Gene, lived in Bellvue. He died in 1992. (H11877.)

Gene Creed, Trick Rider

Mary Geneva "Gene" Creed was as adept as her husband. A famed trick rider, she collected trophies right along with him. She could, a local newspaper said, "bust broncos as well as any man"—quite a compliment given the era in which she competed. Both Creeds were inducted into the Cowboy Hall of Fame in Colorado Springs. (H01972.)

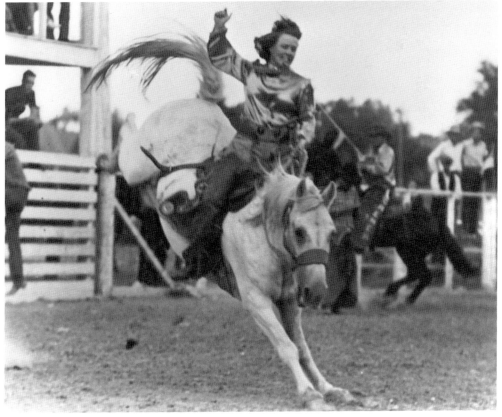

Art Collamer, Stagecoach Driver
Even at 86, in 1980, Art Collamer vividly recalled the days when he drove a four-horse team from Fort Collins to Laramie, a daylong trip of 67 miles, taking seasonal laborers and others to their work. The roads were rough and rocky, he remembered, mostly following Indian trails. Before that time, he had driven a stagecoach until trains replaced the stagecoaches. As a young man, Collamer knew James Naismith, the inventor of basketball. Wounded during World War I, Collamer resumed his route after the war; however, this time he drove a four-cylinder Dodge, delivering wood. He operated a wood yard in town for many years, an enterprise started in 1870 by his father, Frank. Collamer recalled having to buy water for 50¢ a month when he was a boy and stoutly maintained, in his old age, that he would never want to return to "the good old days." (S01916.)

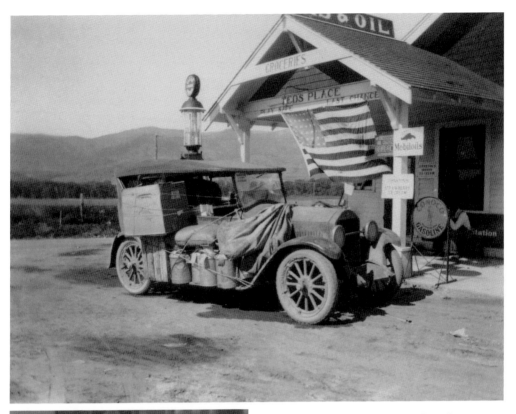

Ted's Place, Legendary Landmark
Even today, many longtime residents still refer to the gas station at the corner of US 287 and Highway 14, the entry to Poudre Canyon, as Ted's Place. Started by Ted Herring in 1922, it became a local landmark. He opened the station with his wife, Nellie, after serving in World War I, selling gas for 5¢ a gallon. It became a favorite stopping place for fishermen. The building was razed in 1989. (H07581.)

Wally Bujack, Policeman
Although he had other careers, including acting, Wally Bujack was well known here in the 1950s as a policeman. Coming here from Hollywood for a visit, he met the woman he would marry and stayed around. He told tales of local bootlegging by one Johnny Boston, who would deliver liquor from his taxicab. Fort Collins was still a dry town, and the enterprise flourished despite the efforts of law enforcement. (T02398.)

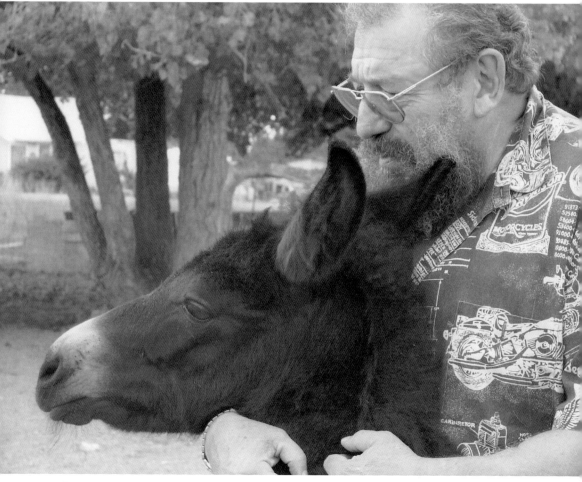

Dr. Bernard Rollin, Bioethicist
Bernard "Bernie" Rollin, shown here with his mule, has always been interested in animals. When he came to Colorado State University (CSU) to teach, he developed the first university course known to cover bioethics, which is medical concern with animal consciousness and pain and consequent humane treatment. The course has been taught at CSU since 1982. Rollin has appointments in three academic disciplines—philosophy, animal science, and biomedical sciences. A distinguished professor at CSU, he lectures frequently all over the world and has written a number of books. In 1985, he helped craft federal legislation dealing with treatment of experimental animals, and has testified before Congress on animal experimentation. He has consulted for governmental agencies throughout the world and has received numerous awards for his work on the welfare of animals. As well, he has assisted other universities in developing courses in animal medical ethics. (Courtesy of Bernard Rollin.)

CHAPTER THREE

Giving Back to the Community

From its beginnings, Fort Collins has been a generous community. People from all walks of life have stepped forward to enrich the town with their time, their talents, their treasures, and their ideas. In times of crisis, the residents could always be counted on to rise to the occasion. The contributions of the individuals and businesses highlighted here are many and varied, from bringing new business or industry to town, to historic preservation, to enlightening and educating the citizenry, and more. In this chapter, readers will meet philanthropists, innovators, educators, physicians, historians, and heroes, among others. Each has brought special, memorable gifts to the town. Each has given or continues to give bountifully in his or her own way.

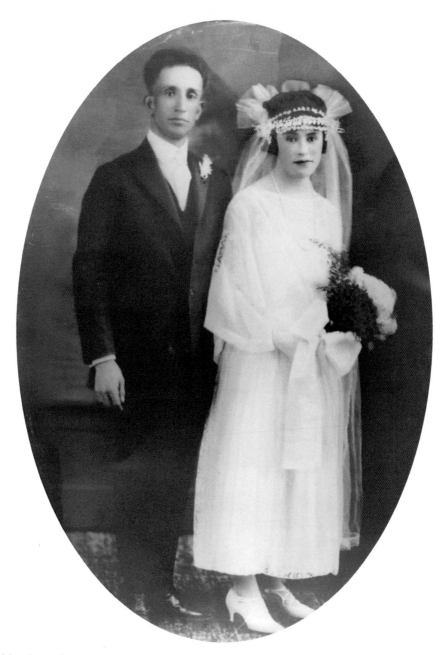

Lee Martinez, Activist

Librado "Lee" Martinez, shown here with his wife, Eva, on their wedding day in 1924, was an effective, persistent spokesperson for the Spanish American community in Fort Collins. After his death in 1970, the city of Fort Collins named a park for him. Just west of the new Museum of Discovery on College Avenue at Cherry Street, the park features a working farm. Martinez, who came to Fort Collins in 1905 at age 16, served in the infantry in World War I. After the war, he farmed and worked as a carpenter, helping to construct Holy Family Church. During World War II, the couple's oldest son, Alonzo, was killed in action. Martinez set up a college scholarship in Alonzo's name for Mexican American students. He served on the city's Human Relations Commission, seeking to improve relations between cultures. (H12394.)

Pauline Birky, Peace Corps Pioneer
Two years spent in Iran and an abiding interest in peace enabled Pauline Birky Kreutzer (front right), shown here with (from left) Betty Ruth and Earl Wilkinson, William and Lilla Morgan, and Martha Trimble, to be hired by the university as a research associate. With Maurice Albertson, she did a study about the feasibility of the Peace Corps and subsequently became a leader in the corps, directing training in several countries abroad. She died in 2008. (H14377.)

Maurice Albertson, Humanitarian
The idea of a Youth Corps, which became the Peace Corps, was developed by Maurice Albertson, an engineering professor at the university. In 1961, he was contacted by Sargent Shriver and invited to Washington, DC, and the corps was born. Albertson worked for climate change mitigation, aided the Mexican American community in removing racial barriers, and earned many awards and honors in his lifetime. He died in 2009. (TR_Albertson.)

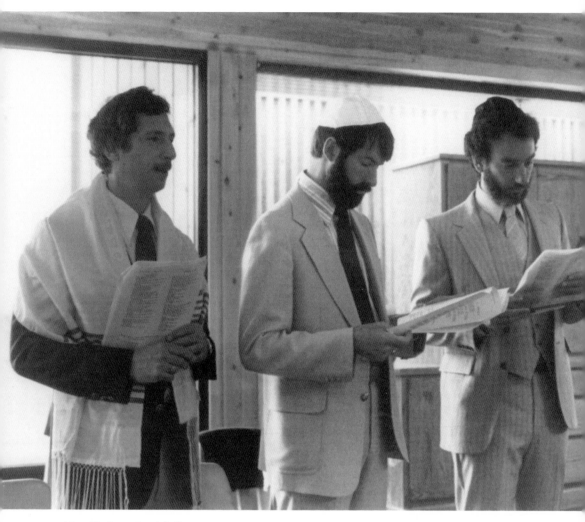

Har Shalom, Jewish Synagogue
This photograph was taken at the dedication of the first Jewish synagogue in Fort Collins, Har Shalom, on West Drake Road, in 1982. The first president of the congregation, Michael Aaronson, is at right. Neil Sherrod is at left; at center is John Hanck. All three men were founders of the congregation, which began in 1976. In the beginning, the small Jewish population saw the need for a religious school, which led to the development of the congregation. As the number of members grew, land purchase and then a building became possible. Not affiliated with a particular sect of Judaism, Har Shalom used visiting rabbis until they were able to hire their own. Aaronson notes that one major accomplishment of the synagogue has been to educate the public school administrators about Jewish holidays. (Courtesy of Sonia ImMasche.)

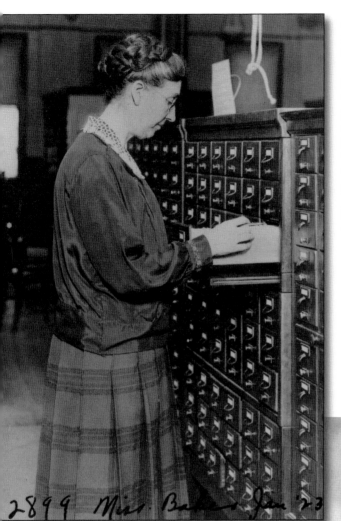

Charlotte Baker, Librarian
Coming to Colorado in hopes of improving her health, Charlotte Baker became the college librarian in 1910. She worked at the library for 30 years and was "a colorful presence" on campus, according to author James Hansen. She insisted on quiet and decorum in the library and would eject those who did not comply. In the 1920s, she was involved in planning a new library building on the oval, and she instituted a summer library school at the college. (H00144.)

Inga Allison, Home Economist
In 1908, when Inga Allison came to the college to join the home economics department, there were no laboratory facilities available. She conducted her research in food preparation and preservation with improvised equipment borrowed from other departments; she also studied the effects of altitude on food preparation. Upon becoming head of the department, she expanded women's studies to include dietetics, child development, and welfare, among other disciplines. (M02780.)

55

Gladys Eddy, Educator

For many decades, Gladys Eddy made a difference at the college—first as a secretary, then as the instigator of the College of Business, later serving as an advocate and instructor, and then as initiator of the campus Mortar Board honor society. In the wider community, she served on school boards, helped establish a local tennis club, and served under Pres. Ronald Reagan on a business advisory board. Her volunteer and professional efforts earned her numerous awards. Eddy died in 2010. (T00194.)

William And Lilla Morgan, Initiators

Under the presidency of William Morgan (1949–1969), Colorado A&M College became Colorado State University in 1957. Morgan came to the college after serving in World War II, seeing the college through the unrest of the 1960s before retirement. The couple is shown here on their 25th anniversary. Lilla Morgan headed the campaign to raise funds for the Lincoln Center in the 1970s. A university memorial fund in her name supports the arts on campus. (Courtesy of Colorado State University Library Archive.)

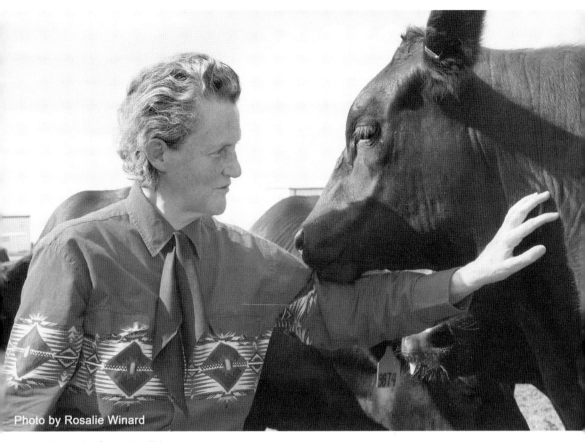

Photo by Rosalie Winard

Dr. Temple Grandin, Educator

Dr. Temple Grandin is known throughout the world as an educator about autism and an advocate for the autistic as well as for her humane designs to keep stock animals, especially cattle, calm. Now a professor in animal science at Colorado State University, Dr. Grandin has developed animal-handling designs that have been adopted widely in the United States and other countries. Unique to her autism, her ability to think in pictures allowed her to understand the animals and envision ways to increase their comfort. She has received numerous awards, including induction into the Cowgirl Hall of Fame, and in 2010, *Time* magazine named her as one of the 100 most influential people in the world. She was the subject of an HBO film, which won accolades from the television industry. Dr. Grandin frequently gives talks about autism; educating others is her highest priority. (Photograph by Rosalie Winard; courtesy of Temple Grandin.)

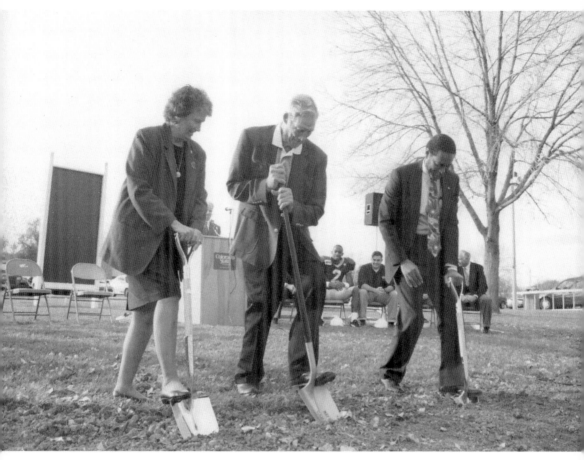

Thurman Mcgraw, Athlete

In this 1997 photograph, Thurman "Fum" McGraw (center) wields a shovel to break ground for the new university athletic center named after him. With him are his wife, Beryl "Brownie" McGraw, and university president Albert Yates. McGraw enrolled in the college as a veteran right after World War II. A gifted football player, he helped the Rams to a winning season in his senior year and went on to play for the Detroit Lions. After leaving professional football, he became athletic director at CSU. Brownie McGraw, a teacher and secondary school principal for many years, served juveniles through the district attorney's office; helped create and raise funds for Inspiration Playground, the first playground for both able and disabled children in Colorado; and has held positions on several local boards. In 1997, the McGraws were named Citizens of the West, an honor bestowed annually through the National Western Stock Show. (Courtesy of Colorado State University Athletic Department.)

Two Outstanding Activists
Between them, Nancy Gray (left) and Ann Azari (right) brought about considerable enrichment in Fort Collins. The street leading into the police station on Timberline Drive is named after Nancy Gray. She became active here soon after she and her husband, Dr. William Gray, moved to Fort Collins in 1961. A member of the League of Women Voters, she served on state boards and from 1973 to 1980 on the city council and was also mayor from 1980 to 1981. She helped establish the Crossroads Safehouse. Equally active in civic affairs, Ann Azari believed in the power of community and devoted considerable effort to helping create private-public partnerships. Coming to Fort Collins with her husband, Paul, and their children in 1963, she served on the city council and was also mayor for three terms, from 1993 to 1999. She initiated the Arts Alive organization and was active in Girl Scouts and Boys and Girls Clubs. Believing deeply in the concept of inclusiveness, she welcomed and sought common ground among different cultures. (Left, courtesy of William Gray; right, courtesy of Victoria Loran.)

Ida Patterson, Nurse
One of the first two nurses at the Fort Collins Hospital was Ida Patterson. The hospital at the southeast corner of Olive and Mathews Streets served patients along with a hospital established nearby by Dr. Peter McHugh at 303 Remington Street. Patterson's photograph was taken in 1890. (H00799.)

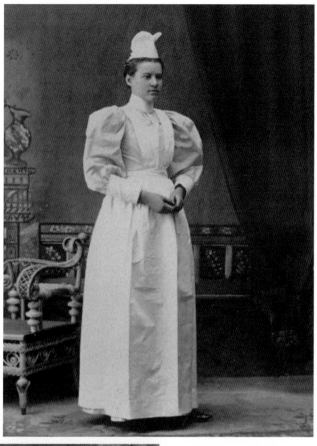

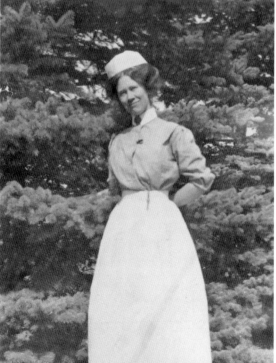

Jane Michie, Nurse
Nurses learned their profession at the Fort Collins Hospital. Jane Michie graduated in 1914, along with five classmates. Michie worked as a nurse at the hospital for three or four years until her father's blindness prompted her to leave nursing to care for him. (H12033.)

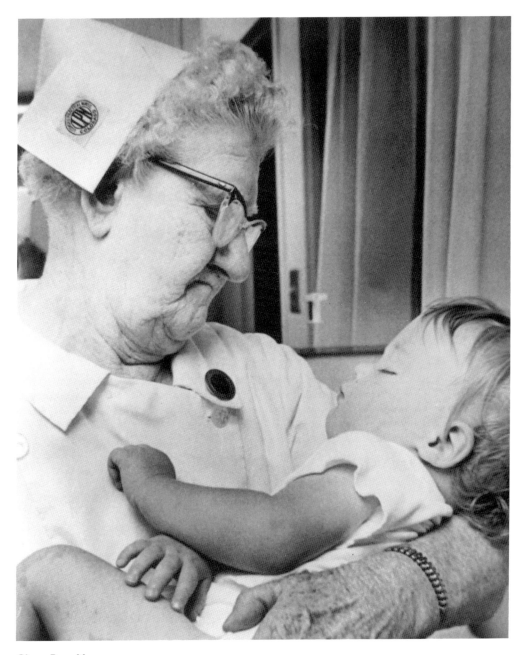

Clara Ray, Nurse
The Larimer County Hospital, built around 1900 on the grounds of the county poor farm on Hospital Road (Lemay Avenue), mainly treated poor farm residents. Clara Ray, a nurse at the hospital, stoked fires and cleaned rooms. She was there day and night. In 1925, a new three-story brick building replaced the old one. Ray continued to work at the hospital, retiring in 1972. The grounds around the hospital were gardened for vegetables to feed the patients, and livestock was pastured there as well. Establishment of the Old Age Pension in the 1930s eliminated the need for the poor farm, and the farm gradually diminished until the 1940s, when it disappeared altogether. By 1950, the city's population had grown, and the need for more hospital space was clear. (H00603.)

F.W. Michael, Leader

F.W. "Bill" Michael accomplished a great deal in his lifetime; one of his most notable achievements was spearheading the campaign to create a hospital district, moving the nonprofit hospital beyond county financial support. A wing of Poudre Valley Hospital is named for him. In the 1970s, he worked tirelessly toward hospital modernization and expansion. Michael also helped establish the Ben Delatour Boy Scout Camp, along with other civic endeavors. (Triangle Review_Michael.)

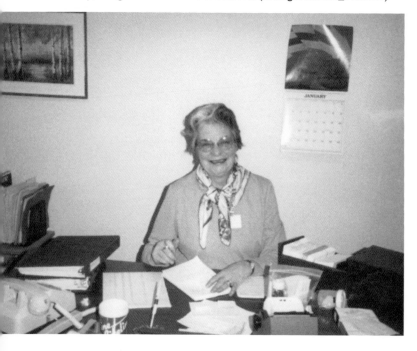

Jean Weitz, Volunteer Director

Seen sitting in the basement broom closet that became her office when she was hired in 1977, Jean Weitz was the first director of volunteer services at Poudre Valley Hospital. She implemented several innovations, including elimination of both the term "candy stripers" to interest boys in becoming junior volunteers, and of adults' pink jackets to encourage men to join. Retiring in 1989, she left her successor a flourishing program. (Courtesy of Jean Weitz.)

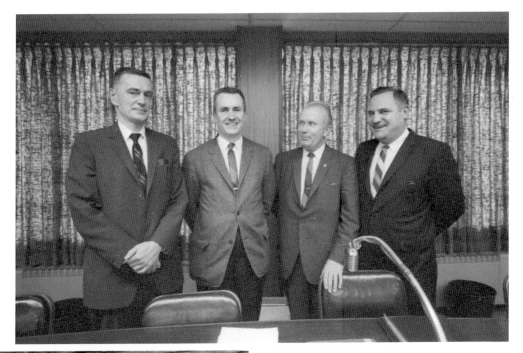

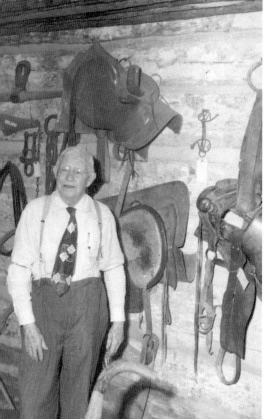

Thomas Bennett, Civic Leader

Dr. Thomas Bennett, a local dentist and descendant of early settler Abner Loomis, was deeply involved in bringing an end to prohibition in Fort Collins, which had been in place since 1895. After considerable campaigning and community discussion, the city council passed an ordinance in 1969 ending Fort Collins's more than seven decades of being a dry town. Pictured are, from left to right, council members Alvin Krutchen, Bennett, Dr. Karl Carson, and Harry Troxell. (C00683.)

Clyde Brown, Curator

Pioneer Museum curator Clyde Brown (from 1943 to 1963) had been a volunteer firefighter 30 years earlier. When he was curator, the museum was located on the grounds of Library Park near the Carnegie Library. In the 1970s, when the new library was completed, the original museum was razed, and the artifacts moved into the Carnegie building on Mathews Street, which became the Fort Collins History Museum. Here, Brown stands in the Janis cabin on the grounds. (H23377B.)

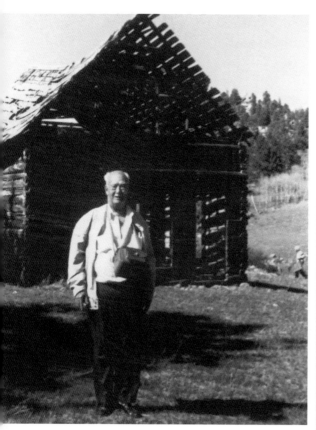

Richard Baker, Historian
Richard "Dick" Baker stands in front of an abandoned mountain cabin. A native of Fort Collins, he graduated from Fort Collins High School in 1929. Instrumental in helping to establish the local history museum, Baker was knowledgeable about local history and mounted a spirited campaign, ultimately unsuccessful, to resurrect the site of the original fort. Baker worked for the city as director of parks and recreation. (H10808.)

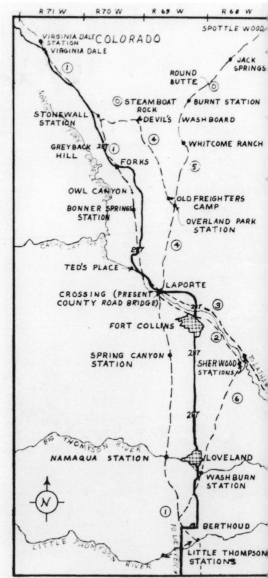

Overland Trail Map
In 1975, Baker revised this map, which shows the Cherokee-Overland Trail in northern Colorado from the Virginia Dale station, north and west of Fort Collins, to Berthoud—essentially, the route of the current US Highway 287. The map was originally drawn in 1942. (H22178.)

Carol Tunner, Preservationist
Carol Tunner, shown here on car No. 21, initiated the restoration of the trolley and aided in the preservation of the downtown area. After overcoming resistance from Mountain Avenue residents, the streetcar began operation again in the summer of 1984. She wrote grants to restore several hotels and the Silver Grill restaurant, among other efforts, and served as the city preservation specialist for 12 years. (Courtesy of Carol Tunner.)

George Beach, Soldier
Holder of a 1910 diploma from Fort Collins High School and a 1914 bachelor's degree from Massachusetts Institute of Technology, George Beach enlisted when the United States joined World War I in 1917. He was killed in action in January 1918, the first Larimer County casualty of the war. (M06826.)

Stanley Case, Resort Owner
From the late 1940s, after his return from World War II, Stanley Case and his wife, Lola, owned the Arrowhead Lodge in Poudre Canyon until 1984, when the US Forest Service purchased it. The lodge, a popular gathering place in its time, is now a visitor's center. Case, who managed the city power plant for years, wrote a definitive history of Poudre Canyon. (H23204.)

Dan Beattie Camp
1926 graduate, Dan Beattie was a champion athlete at Fort Collins High School. He became a high school coach and had a distinguished career in education during the 1930s through the 1950s and in administration until his retirement in 1971. Shown here is the Dan Beattie Boys' Camp for troubled boys in Poudre Canyon, which operated in the summers during the 1950s. Beattie Elementary School is a Beacon School for the Talented and Gifted. (H07888.)

Three Notable Women
Each of these women, from left to right, Betty Woodworth, Charlene Tresner, and Martha Trimble, had a significant impact on the community. Woodworth, granddaughter of Franklin Avery, was the society and features editor at the Fort Collins *Coloradoan* for 32 years, retiring in 1976. Tresner, a librarian, started an archive at the Fort Collins Public Library in 1974 and was the city's first archivist. Like Woodworth a native of Fort Collins, she wrote a book, *Streets of Fort Collins*, and often wrote historical columns for the local newspaper. She died in 1990. Trimble, who served in the WAVES during World War II, was the daughter of pioneers. She became an English professor at the college after the war and was involved in the establishment of a learning laboratory for students. She also nurtured and supported the Trimble Court Artisans downtown. (H16534.)

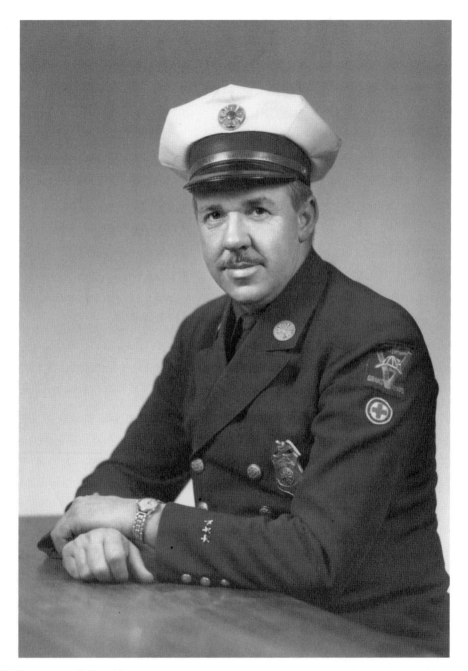

Cliff Carpenter, Fallen Hero
"There's a fire at State Dry Goods," said an anonymous voice on the telephone the night of June 28, 1965. The store, located at the northwest corner of College Avenue and Oak Street, was indeed ablaze. Fire Chief Clifford Carpenter took charge of the battle. Luckily, the store and offices above were empty; no lives, they thought, would be lost. Then, the unexpected happened—the south wall of the building crumbled and fell directly onto the chief and fireman James Wichtel. After frantically digging through the rubble, the crew found their chief dead and Wichtel badly injured. Before the fire was out, a drugstore and bookstore were also destroyed, with losses in the millions of dollars. (H07378.)

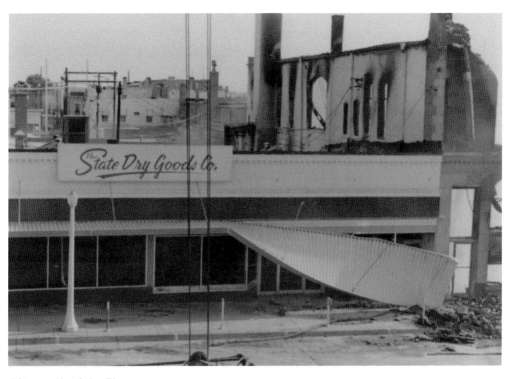

Aftermath of the Fire

These photographs show the aftermath of the fire, which may have been started by two boys playing with firecrackers. (Above, H23406D; below, H01937.)

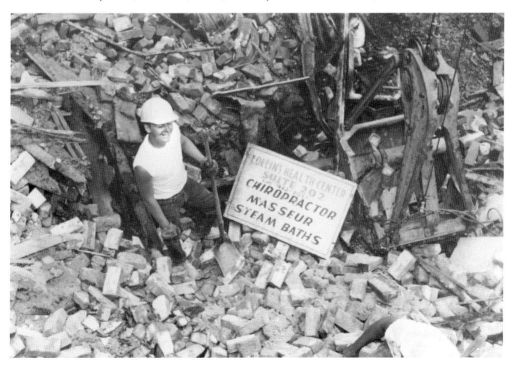

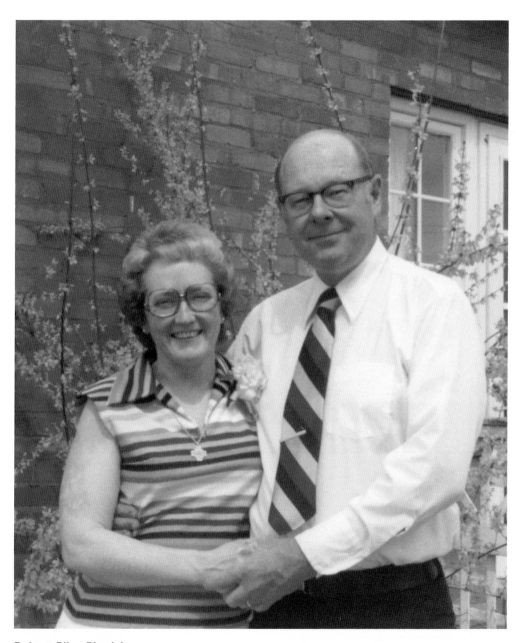

Robert Pike, Physician
Robert Pike, shown here with his wife, Marian, around 1990, was a 1947 graduate of Fort Collins High School (FCHS) and an enthusiast for his alma mater all his life. After serving in the Navy during the Korean conflict, Pike graduated from the University of Colorado School of Medicine and returned to his hometown to open his practice in 1965. Dr. Pike attended every FCHS football game, home or away, from 1965 to 1999. Concerned that there was no attending physician on the field, he became the high school's football physician, a practice that was soon adopted officially by other high schools. The football field at the new Fort Collins High School bears his name. Dr. Pike wrote a history of the high school, operated a clinic at Lincoln Junior High School for a time, and served as an official physician for US Olympic teams. He died in 2000. (Courtesy of Marian Pike.)

Sr. Mary Alice Murphy, Humanitarian
Sr. Mary Alice Murphy's humanitarian work touches all of Fort Collins. Coming here in 1983, a member of the Victory Noll Sisters, she worked on behalf of the poor and homeless. Sister Murphy directed Catholic Charities, started a food bank and a job bank at St. Joseph's Catholic Church, and helped develop an apartment complex for the homeless. She also founded Hand Up Cooperative, now Homeless Gear, which helps homeless people become employed. (Courtesy of Homeless Gear.)

Rev. Robert Geller, Campus Minister
From 1962 to 1990, Rev. Robert Geller, shown here with his wife, June, served as the Colorado State University campus minister. In 2011, the Geller Center for Spiritual Development on Howes Street celebrated Reverend Geller's 90th birthday. Geller started a rape hotline and the first hospice program here, served as part-time chaplain at Woodward Company, initiated the technique of group counseling, and helped found the Volunteer Clearinghouse, among other accomplishments. (Courtesy of Libby James.)

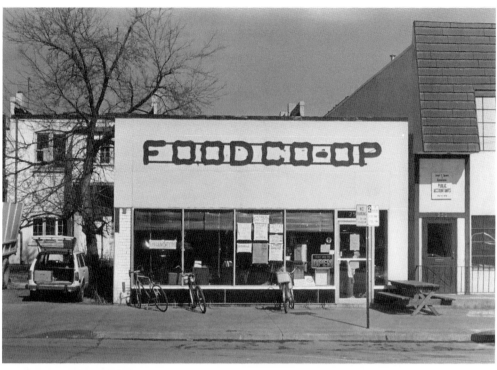

Food Co-op, Member-Owned
The Fort Collins Food Co-op, a not-for-profit grocery store on East Mountain Avenue, started in 1972; it is pictured around 1975. Members have shares in the store and can work for discounts. The store, which sells to both members and non-members, offers locally grown, organic products, member discounts at other local merchants, bulk products, and an in-house deli. Having outgrown its current facility, the store is looking for a larger space downtown. (Courtesy of Fort Collins Food Co-op.)

Merrill Steele, Independent Grocer
Having experience since childhood in the grocery business, Merrill Steele opened Steele's Cash Food Market on East Oak Street in 1940, featuring a window doughnut machine that charmed children. In 1963, the market moved to West Mountain Avenue. Faced with chain-store competition, the Mountain Avenue store and others here and elsewhere were forced to close in 2001. Steele is shown here with his wife, Pauline, and their children, Carol Ann and Robert. (H31696.)

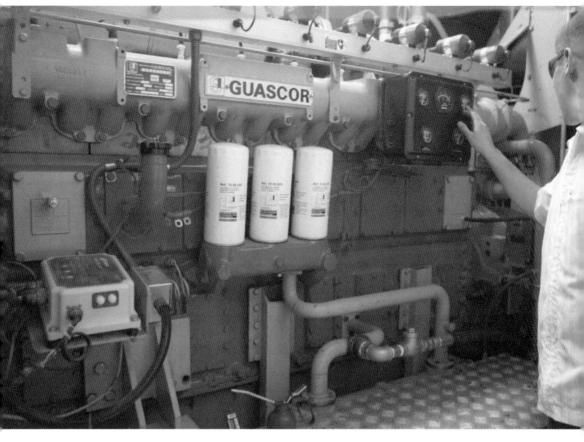

New Belgium Brewery, Innovators

New Belgium Brewery, which began in 1989 with home-brewed beer in Jeff Lebesch's basement, is known throughout the country for its brews, its sustainable-energy plant, and its local community activities. Lebesch's wife, Kim Jordan, is now the company's CEO. Opened in 1991, the employee-owned company became the first wind-powered brewery in the country in 1998. New Belgium annually sponsors the Tour de Fat, a colorful bicycle parade that draws participants from around the area, and the Be Local event, as well as various events in other towns and cities where the beers are distributed. The company also cooperates with Homeless Gear to provide employment for the organization's clients. New Belgium has the largest photovoltaic array in the country and is a community leader in sustainable energy use. Shown here is the company's co-generator, which can produce either heat or electricity. (Courtesy of New Belgium Brewery.)

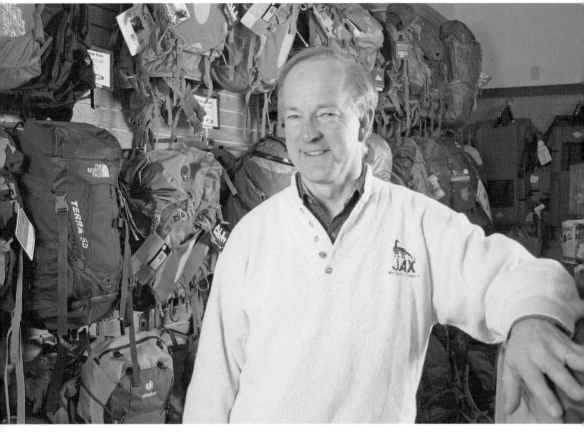

Jim Quinlan, Jax Mercantile Owner

For decades, since 1953, Jax Surplus on North College Avenue sold surplus military equipment. Then in 1986, Jim Quinlan purchased the store, and it became Jax Outdoor Gear, which offers a wide array of merchandise from boots to books. The unique store is listed in some guidebooks as a local tourist destination. In 2001, the family-owned store expanded to open Jax Farm and Ranch, farther north on US Highway 287. The family also owns stores in Loveland, Lafayette, and Ames, Iowa, where the Jax story began in 1955 with a military-surplus store operated by Quinlan's parents, Marvin and Lola Quinlan. Annually, the store sponsors Author Day, with local authors having the opportunity to display and sell their works. Though otherwise retired, Quinlan's mother oversees the event. (Courtesy of Jim Quinlan.)

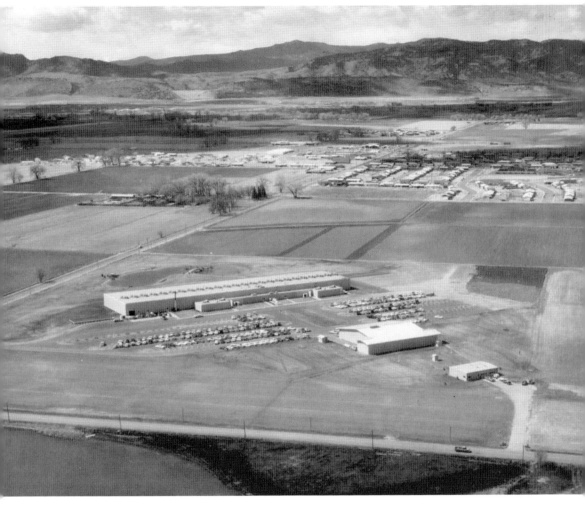

Woodward Inc., Industrialists
The arrival of Woodward Governor in 1955, with its first plant on Riverside Drive, marked a turning point in the community's history. At the time a manufacturer of machine governors, this company brought jobs and infused energy into the local economy and continues to do so. The present plant at the corner of Drake Road and Lemay Avenue was built in 1966. In the 1990s, longtime employee Henri Siedow recalled a significant change in the company's culture when the expectations of the former CEO, Irl Martin, about employees' appearances were relaxed and male employees were allowed to dress less formally and have facial hair if they chose. After a downturn in the 1990s, the company expanded its product line, moved its headquarters to Fort Collins, and continues to thrive. The aerial view shown here is of the plant in 1966. (Courtesy of Woodward Legal Department.)

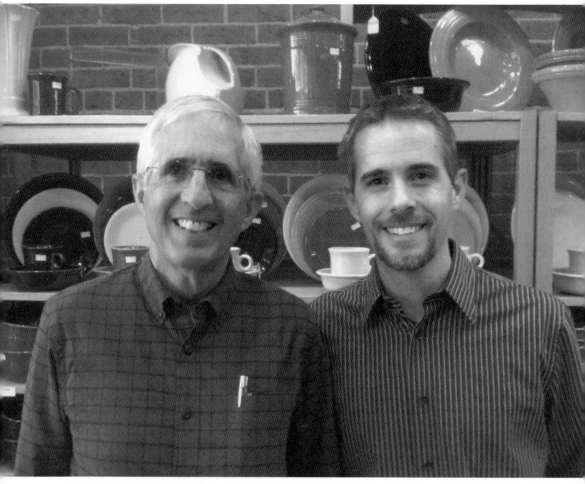

Carey Hewitt, Merchant
A downtown institution for 40 years, The Cupboard, owned by Carey Hewitt, offers specialty kitchen equipment and supplies and features cooking demonstrations and classes. Hewitt, shown here with his son, Jim, who now works at the store, knew nothing about the retail business when he started his store in a small space in the Northern Hotel in 1972. In 1977, an explosion at the Elks Building on East Oak Street took 50 feet off the back of the building the store now occupies on South College Avenue. Hewitt has been a longtime advocate for improving the appearance of College Avenue and served for 18 years on the board of the Downtown Development Association. His store was the first recipient of the chamber of commerce Small Business of the Year Award. (Courtesy of Carey Hewitt.)

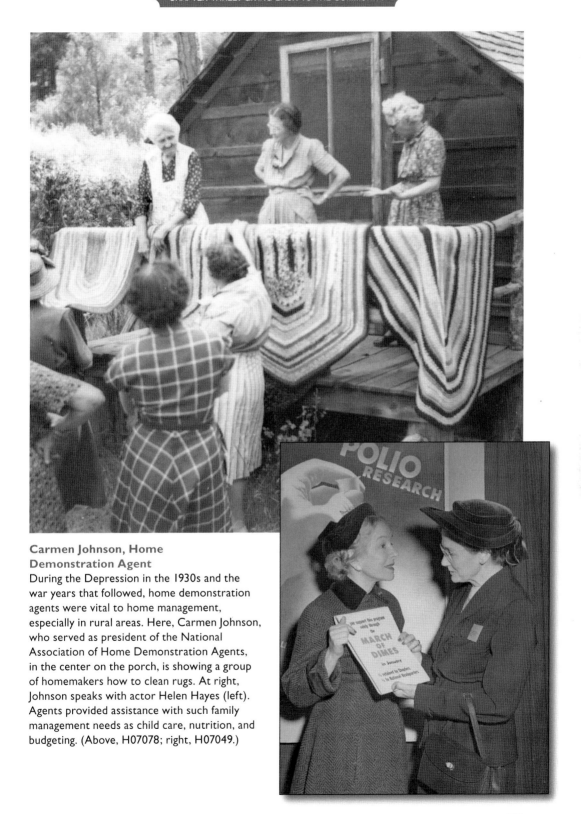

Carmen Johnson, Home Demonstration Agent

During the Depression in the 1930s and the war years that followed, home demonstration agents were vital to home management, especially in rural areas. Here, Carmen Johnson, who served as president of the National Association of Home Demonstration Agents, in the center on the porch, is showing a group of homemakers how to clean rugs. At right, Johnson speaks with actor Helen Hayes (left). Agents provided assistance with such family management needs as child care, nutrition, and budgeting. (Above, H07078; right, H07049.)

Hope Sykes, Writer

Hope Sykes, who taught immigrant children at Plummer School during the 1930s, wrote a definitive book about the lives of German-Russian immigrants who worked the sugar beet fields. *Second Hoeing*, first published in 1935, tells the story of a young girl who works in the fields alongside her parents and siblings, vividly describing the backbreaking tasks the fieldworkers did. The book shone a harsh light on a lifestyle unknown to more prosperous local residents. (H08455.)

Foothills Gateway Inc.

For 40 years, Foothills Gateway has helped developmentally disabled clients master skills that will enable them to integrate into the community and hold down jobs. The agency starts working with young children to enable them to attend school when they are old enough. Upon graduation, the agency continues to provide clients with coaching and guidance after they leave the facility. Foothills Gateway serves clients in both Fort Collins and Loveland. Clients like the one pictured here grow in confidence and daily management of tasks. (Courtesy of Foothills Gateway.)

CHAPTER FOUR

Nurturing the Culture

In the 1880s, a group of enterprising businessmen sought to change the perception of Fort Collins as a mere "cow town" with no cultural life. Working together, they developed the Opera House on North College Avenue, a venue that featured entertainments of many types—operas, plays, performers, lecturers, poets, and writers—suitable for families.

Then along came motion pictures. The entertainments so enjoyed by the populace for three decades lost favor, and the opera house faded into history. After a relative dry spell during the 1930s through the 1950s, the cultural scene here began to flower. Early cultural endeavors included a community orchestra and community theater (the first of which was the Fort Collins Children's Theatre), along with cultural contributions from the university, but with the renovation of Lincoln Junior High School into the Lincoln Center for the Performing Arts, the theater and music scene blossomed. Now, Fort Collins is a flourishing center for culture in Northern Colorado, with art galleries, community theaters, a ballet company, children's theaters, a full orchestra and chamber orchestra, and choral groups, along with a variety of other cultural offerings. The music scene caters to a wide variety of tastes. Today, all sorts of cultural flavors thrive here.

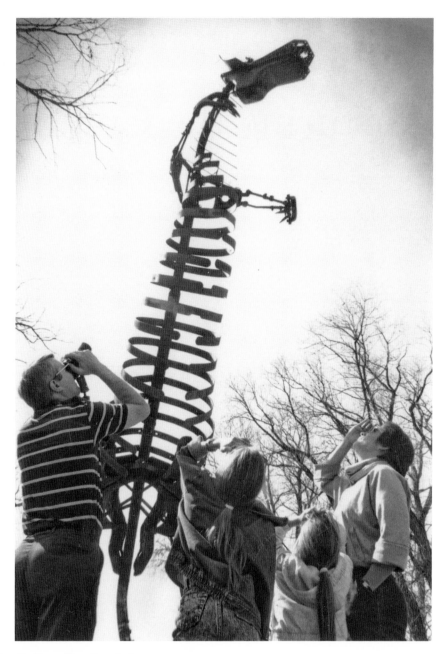

Swetsville Zoo, Creative Art
Travelers going north along Interstate 25 could not miss the metal dinosaur sculpture gracing the roadside near the Timnath exit. A local landmark for decades, the figure was part of the Swetsville Zoo along the Poudre River in nearby Timnath. Owner Bill Swets, once a farmer, began building sculptures from scrap metal, farm machinery, and car parts in 1985; gradually, the "zoo" grew to include over-sized insects and birds, among other exotic creatures, and a band. From time to time, a new piece would appear when Swets was seized with inspiration. Admission was free. A car hit the giant sculpture on the highway a few years ago and damaged it, and construction and growth spelled an end to the zoo on East Harmony Road in 2009. Some sculptures have been preserved. (Triangle Review_Swets.)

Fort Collins Children's Theatre
One of the first, and most enduring, community theater programs in Fort Collins is the Fort Collins Children's Theatre. Started in 1958 by the three women shown here, from left to right, Joyce Everitt, the late Marguerite Johnson Baily, and Sarah Bennett, along with others, the theater group seeks to expose children to live theater with plays that are shared by families. It was the first community theater company to produce a play on the new Lincoln Center stage. The nonprofit group is supported by grants from the Downtown Development Association, Fort Fund, and other organizations. Every summer, the Peanut Butter and Jam Revue workshop offers children, ages 10 to 14, a chance to be in a performance and do technical tasks, and the theater group puts on an annual production in the fall. (Photograph by John Clarke; courtesy of John Clarke.)

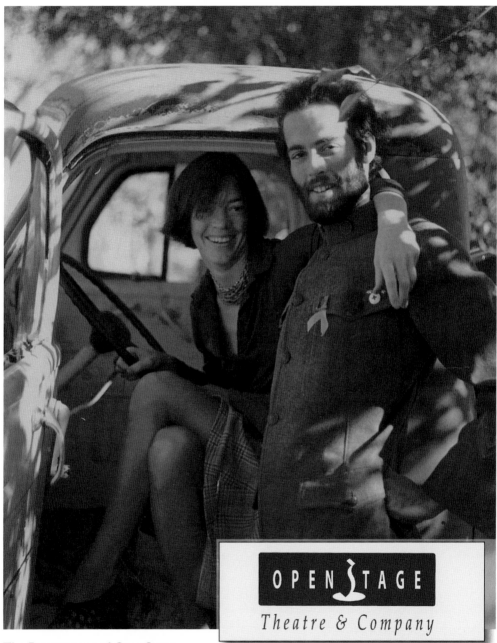

OPEN STAGE
Theatre & Company

The Freestones and OpenStage

When Bruce Freestone said to his wife, Denise, in 1973, "Let's start a theater," she replied, "You are insane." But start it they did, and OpenStage Theatre was born, first performing in City Park in August of that year. The couple, who met at CSU, are still at the helm of the thriving regional theater company, which performed in a variety of venues until the opening of the new Lincoln Center. Denise Freestone is artistic director. She says that theater "can create a sacred space that crosses ethnic, social, and religious boundaries." OpenStage received the 2011 Henry Award as an outstanding regional theater. Though nonprofit, performers are auditioned and compensated for the five to seven performances each year. (Courtesy of Bruce and Denise Freestone.)

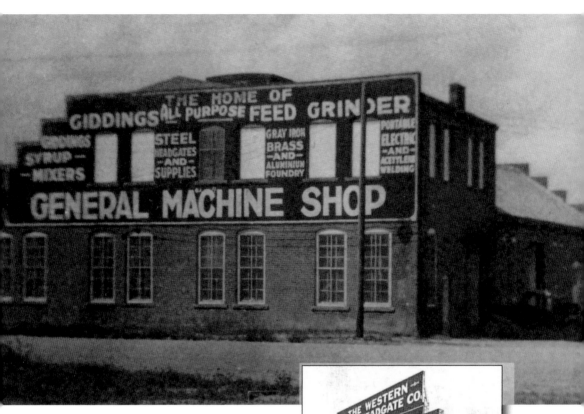

Bas Bleu Theatre, Salon

Over margaritas at a restaurant, Wendy Ishii and Eva Wright founded the Bas Bleu Theatre Company in 1992 with a goal of creating a venue for theater, art, and thought-provoking conversation. They expected it to last only a few years; 20 years later, the theater company is hoping to remodel its building space into a contemporary theater and art gallery. Now artistic director, Ishii recalls the theater's beginning in a small theater space in Old Town. In 2007, the company purchased the old Giddings Manufacturing Plant on Pine Street, shown here. The remodeled theater, designed by BOORA Architects, will incorporate all aspects of the theater's purpose—dramatic performance, education, art appreciation, and discussion. (Above, H25233; right, courtesy of Bas Bleu Theatre Company.)

The Mostlies, Comedy Troupe

No one today can imagine Fort Collins without the Mostlies, a parody group that began creating spoofs on just about everything, local, state, and national, in 1992. Started by Betsy Kellogg, Betsy Noland-Davis, and Patty Bell, along with others, the group never thought they would continue for 20 years and more. They now perform at the Magnolia Theatre in the Lincoln Center, putting on a popular annual show, with a special show during presidential election years. (Courtesy of Steve Noland.)

Debut Theatre Company

Children as young as six can begin to learn about the world of theater through the Debut Theatre Company, founded and led by Lee Osterhout-Kaplan and Gregg Osterhout, who are shown here amidst the cast of *Phantom of the Opera*. Students learn acting basics, body movement, and theater terminology and they stage plays. The Debut Players, ages 11 to 17, put on a public performance of classic literature every spring at the Lincoln Center. (Courtesy of Lee Kaplan.)

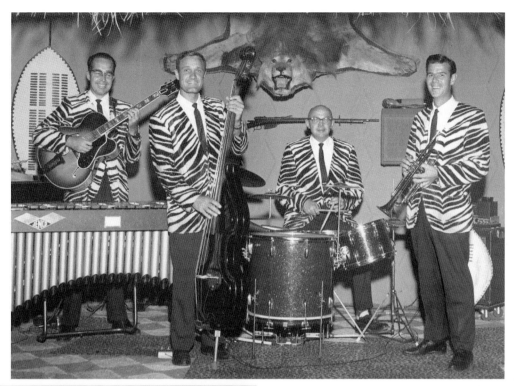

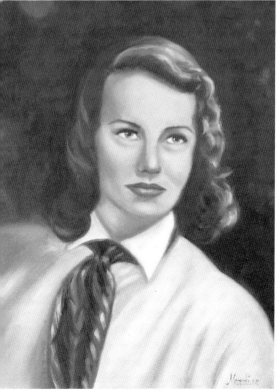

Bob Swerer, Musician

Almost anyone living here in the 1960s and 1970s is familiar with Bob Swerer, who began his career as a musician on the radio. He opened his famed Safari Club in 1962. Members of the Bob Swerer Band, shown here from left to right, Bob Hatton, Swerer, Bob Kelley, and Jim Stevens, entertained guests who dined and danced at the club until it closed in the 1980s. Swerer now makes and sells adventure videos. (Courtesy of Bob Swerer.)

Jeanne Nash, Artist

The Global Village Museum at West Mountain Avenue and Mason Street, opened in 2011, had long been a dream of the late Jeanne Nash, who was an artist and collector. Nash made pottery, wove, and knitted and, when she traveled, she collected miniatures. Her miniature collection is on display at the museum. Nash also helped found the Trimble Court Artisans and Operation Bookshelf, which sends books and supplies to children in Latin American countries. (Photograph by Malcolm McNeill; courtesy of Heidi Nash.)

Editha Leonard, Violinist

Editha Todd Leonard began playing the violin as a child, as the photograph shows; she founded the Fort Collins Concert Orchestra in 1923 and led it through the 1930s. She had a music studio for many years in Fort Collins and left several arts endowments following her death in 1999. A graduate of the Chicago Music School, she served as the Fort Collins Symphony Orchestra concertmistress for several years, starting in 1949. (H20883.)

Fort Collins Concert Orchestra

Predecessor of the Fort Collins Symphony Orchestra, the Fort Collins Concert Orchestra provided classical music to local audiences for nearly two decades. In this photograph taken at the Methodist-Episcopal Church, Editha Leonard is third from the left in the first row. Her sister Margaret Todd is at the piano. This was the first classical music organization in Fort Collins. (H20225.)

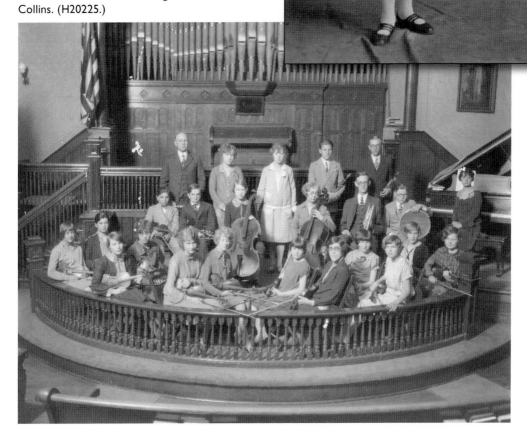

Will Schwartz, Maestro
Will Schwartz founded the local symphony orchestra in 1949. He came here to teach music at the college and soon began conducting the concert orchestra, which grew in size and stature to become the Fort Collins Symphony Orchestra, and remains the only professional symphonic orchestra in Larimer County. Maestro Schwartz, a violinist, led the orchestra for 50 years. (Courtesy of Lisa Schwartz and the Fort Collins Symphony Guild.)

Wes Kenney, Maestro
The current conductor of the symphony orchestra is Wes Kenney, like Schwartz a professor of music at the university, who has conducted the orchestra for 10 years. Kenney, who led an orchestra in Virginia before coming here, now holds nationwide auditions for a place in the orchestra. He also conducts for Opera Fort Collins, university orchestras, and Canyon Concert Ballet. (Courtesy of Wes Kenney.)

Elizabeth Elliott, Vocalist

Elizabeth Elliott came to Fort Collins in 1979 and worked as music director at the university radio station, which needed funds. She staged an opera to raise money for the station, and an opera company was born. For a time, it was under the auspices of OpenStage Theatre. After nonprofit incorporation as Opera Fort Collins in 1991, Elliott was artistic director for five years. The company offers one opera performance each year. (Courtesy of Elizabeth Elliott.)

Larimer Chorale

In 1977, Elizabeth Elliott put an advertisement in the newspaper for singers to start a choral group; 100 people showed up. Larimer Chorale began in December of that year, becoming an official nonprofit in 1979. Now an auditioned chorus with most singers being serious students of music, the chorale of more than 100 voices, which has performed in Europe, is led by Michael Todd Kreuger and typically gives three one-night performances each year. (Courtesy of Wendy White and the Larimer Chorale.)

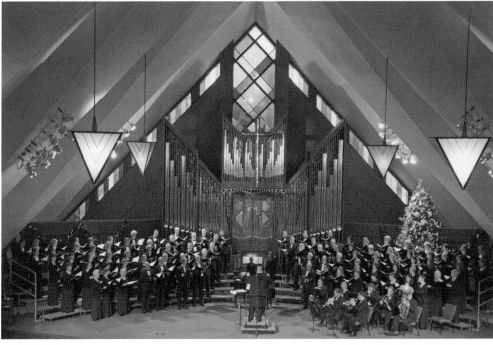

Joy Davidson, Opera Singer
Joy Davidson, a Fort Collins native, graduated from Fort Collins High School in 1959 and never imagined she would become an opera singer. After singing in high school choruses, she discovered, while in college, that she had an operatic-quality voice. In 1965, when performing in Miami, where she and her family had moved, she was heard by Rise Stevens and subsequently received a one-year contract with the Metropolitan Opera in New York City. In Miami, she developed an opera department at the New World School of the Arts and, after retiring from opera, she performed several one-woman shows, including performances as Alice Roosevelt Longworth, Maria Callas, and Katherine Hepburn. Davidson has fond memories of the small town where she grew up. (Courtesy of Joy Davidson.)

Robert Cavarra, Organist
Designer of the Casavant Freres organ, the first mechanical organ at a university, Robert Cavarra (right, with an unidentified student) traveled widely to study organ construction and designed the Casavant to resemble 17th-century German organs. Besides the university's organ, Cavarra was responsible for installation of the Lawrence Phelps Opus 1 organ at St. Luke's Episcopal Church and the Marcussen organ at the First United Methodist Church. In its new home at the University Center for the Arts, the Casavant organ's over 2,000 pipes rise 19 feet and cover an entire wall. Cavarra, who died in 2008, was a world-renowned organist and recitalist who performed in the United States, Europe, and Canada. He was instrumental in reviving interest in organ performance and brought international acclaim to the university, where he taught from 1963 to 2000. (H23302.)

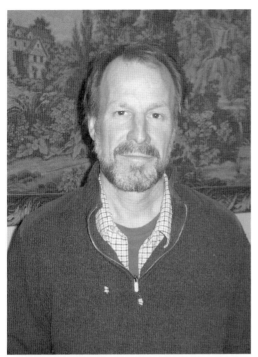

Rob Osborne, Restaurateur
Avogadro's Number is known as a music venue as well as an eating place. Though the restaurant has been on Mason Street, near campus, for 40 years, Rob Osborne, the current owner, has only had it for about 30. He bought it in 1980 after owning an ice cream parlor in Boulder. Local musicians, from jazz to opera, have performed on the stage attached to the restaurant. A backyard patio also offers entertainment space. (Courtesy of Rob Osborne.)

Mark Sloniker, Jazz Pianist
After being the house pianist at the Broadmoor Hotel in Colorado Springs, Mark Sloniker came to Fort Collins to join a band in 1981 and stayed. Sloniker gives lessons in piano, composition, and music theory in his home studio and often performs solo or with other musicians. He holds a degree in music therapy from CSU. (Photograph by Amanda Constant; courtesy of Mark Sloniker.)

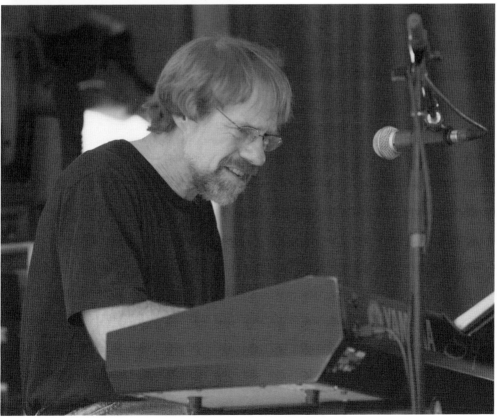

Canyon Concert Ballet

Carol Torguson started the Canyon Concert Ballet in 1979, and it has been going ever since. The ballet company performs twice a year, offering the *Nutcracker Suite* in the holiday season and another ballet in the spring. One of the first to audition was Lou Ann Yee, whose daughter Elizabeth is shown here in the studio. The ballet company trains about 400 dancers each year in every form, from modern dance to classical ballet. (Courtesy of Elizabeth Yee Erickson.)

Storm Mountain Folk Dancers

Since 1972, the Storm Mountain Folk Dancers have been practicing and performing a variety of traditional dances from various countries. They hold an open dance at the Empire Grange on West Mulberry Street on Thursday nights and teach some of the dances. The dance group, co-directed by Bill Poole and Wendy Kiss, consists of about a dozen experienced dancers who provide their own costumes and have appeared at numerous area events over the years. (Courtesy of Storm Mountain Folk Dancers.)

Museo de las Tres Colonias
A small, colorful adobe house on Tenth Street in Andersonville became a museum of Hispanic heritage in 2006. Co-founder Betty Aragon stands with Carmel Solano in front of the museum, which once was the home— one bedroom, a living area, a small kitchen, and a cold room, with no indoor plumbing—of the Romero family. The museum represents life for Hispanic sugar beet workers from 1927 to 1940. (Courtesy of Betty Aragon.)

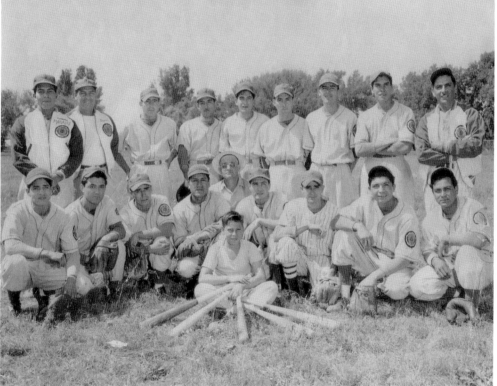

Fort Collins Legionnaires
Baseball was a consuming part-time interest among young Hispanic beet fieldworkers, resulting in the formation of the Spanish Baseball League, which also went by other names. Teams, including the Fort Collins Legionnaires, formed in several neighboring towns during the 1930s. The players, who made their own gloves from rags, liked to play on a real field in City Park rather than the usual cow pastures with attendant hazards. (Courtesy of Jodi and Gabe Lopez. See their book, *From Sugar to Diamonds*, for names of the players.)

Clara Hatton, Educator

Clara Hatton, who created the art department at the college, loved teaching. When her niece, Ora Shay, was 12, Hatton guided her and a friend through the intricacies of this mosaic, a representation of Roman art. Shay learned not only skill but patience through the lesson. The art gallery at the University Center for the Arts is named for Hatton, who began her teaching career in the Home Economics department and created works in watercolor and oils, as well as design and calligraphy. She died in 1991, age 90. (Courtesy of Ora Shay.)

Agnes Lilley, Artist

A retired teacher, Agnes Lilley moved to Fort Collins in 1961. She was active in the Women's International League for Peace and Freedom, the League of Women Voters, the Poudre Art League, and the Tuesday Morning Sketch Group. Here, she is seen sketching during one of the group's Tuesday outings. Lilley died in 1991. (H22719.)

Mary Bates, Artist and Activist
In this photograph, artist Mary Bates (left) is seen with Agnes Lilley. Bates, an artist and peace activist, was one of the founders of Trimble Court Artisans. She had seen artists' cooperatives abroad and brought the idea back to Fort Collins. Bates was the author of a book published by CSU, *Survival Through World Peace*, in 1978 and was a candidate for Congress on a peace platform. (H22864.)

Trimble Court Artisans
Tucked away off College Avenue, leading to Old Town Square, Trimble Court houses shops including Trimble Court Artisans, a local artists' cooperative founded in the 1970s with the generous support of Martha Trimble, who rented the building to the artists' group for a minimal fee. About 50 local artists provide paintings, weaving, sculpture, and jewelry for sale in the store, sharing profits with the store management for maintenance and staff. All accepted work is juried. (T02904.)

Barbara Moore, Artist
Having moved here in 1988, watercolor artist Barbara Moore fell in love with Old Town and ever since has been painting landscapes of downtown and other local scenes. She has won numerous awards for her work, including honorable mention in the national Irving Shapiro Memorial Award. Collectors in this country, England, Canada, and Japan own her paintings. Several businesses in Fort Collins display her works, among them Wells Fargo Bank and the Silver Grill restaurant. Moore focuses on "creating lasting impressions of Rocky Mountain country." The watercolor on this page, titled "Drink Coke," shows a scene in Old Town Square, with a ghost sign clearly visible on the building. (Courtesy of Barbara Moore.)

Larry Webber, Librarian
From 1966 until 1982, Larry Webber directed the Fort Collins Public Library, during which the library relocated from the Carnegie building on Mathews Street to the new building on Peterson Street, immediately east of the original site in Library Park, in 1974. In 2006, the library became the Poudre River Library District, and in 2011–2012, voter-approved expansion of the facility took place. (H00788.)

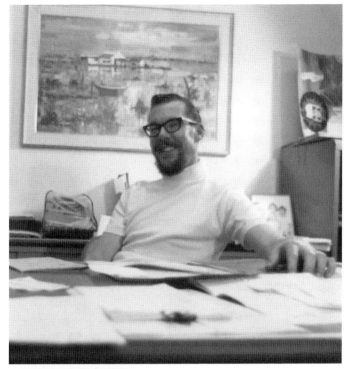

Annie, the Railroad Dog
Few children can walk past the appealing sculpture of Annie, the Railroad Dog, in front of the public library, without stopping to pat her. Sculpted by Dawn Weimer, the statue tells the story of a little pregnant dog adopted by railroad workers in 1934. Living at the railroad station, she greeted and charmed disembarking passengers for 14 years, until her death in 1948. One special friend, Chris Demuth, took her for walks around downtown. During the annual Annie Walk, people and their dogs honor her memory. (H21411.)

Wes and Stephanie Webb, Holiday Twin Drive-In

People might suppose that drive-in movie theaters are a thing of the past—not so. Around 400 of them exist around the country, with more being built, and one of them, the Holiday Twin on Overland Trail, has been here since 1972. Wes and Stephanie Webb gained ownership of it in 1979. During the season, April to September, customers come from Cheyenne, Loveland, Longmont, Greeley, and even as far as Denver and Estes Park to watch films from their cars; some patrons bring tailgate picnics or host birthday parties at the drive-in. Families like to come on weekends. Though there have been and will be challenges, such as converting to digital projection, the Webbs plan to stay as long as the theater is profitable. "It's our community," says Stephanie Webb. (Photograph by MEM, courtesy of Wes and Stephanie Webb.)

CHAPTER FIVE

Living an Ordinary Life–Extraordinarily

As one walks down a street in Fort Collins, he or she encounters ordinary people, going about their business as ordinary people do. But among them are ordinary people living extraordinary lives, whose impact might not be known in their lifetimes. This has been true of the town since its beginning—relatively unknown people making a difference in this community and beyond. They have been and are homemakers, educators, entrepreneurs, public-minded citizens, or perhaps volunteers for a favorite cause; there are too many occupations to list. Some have been through a life-changing experience. Others have accomplished their goals with quiet persistence. Each of them has a unique tale to tell.

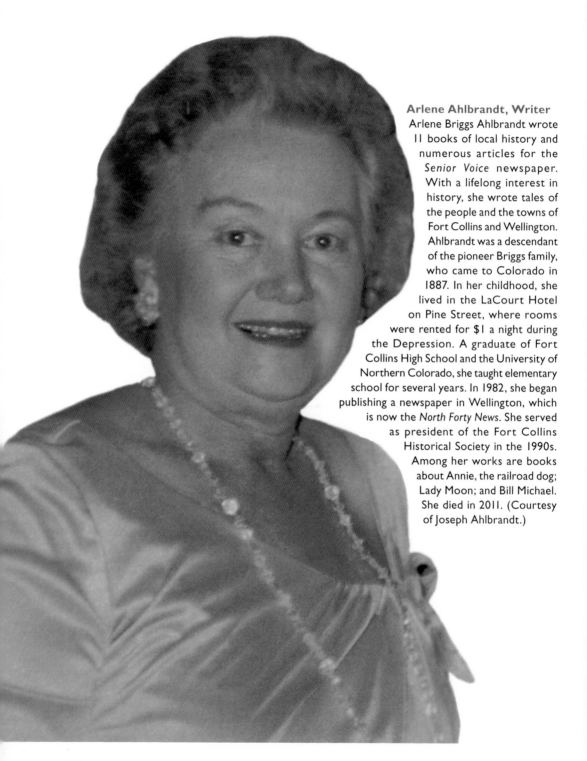

Arlene Ahlbrandt, Writer
Arlene Briggs Ahlbrandt wrote 11 books of local history and numerous articles for the *Senior Voice* newspaper. With a lifelong interest in history, she wrote tales of the people and the towns of Fort Collins and Wellington. Ahlbrandt was a descendant of the pioneer Briggs family, who came to Colorado in 1887. In her childhood, she lived in the LaCourt Hotel on Pine Street, where rooms were rented for $1 a night during the Depression. A graduate of Fort Collins High School and the University of Northern Colorado, she taught elementary school for several years. In 1982, she began publishing a newspaper in Wellington, which is now the *North Forty News*. She served as president of the Fort Collins Historical Society in the 1990s. Among her works are books about Annie, the railroad dog; Lady Moon; and Bill Michael. She died in 2011. (Courtesy of Joseph Ahlbrandt.)

Laura Makepeace, Librarian
In 1918, after several years of teaching in rural schools, Laura Makepeace joined the library staff at the college. A world traveler in later years, she was also a mountain climber and developed a course in library science at the college. She served as executive librarian at the university and gave Fort Collins historians the valuable gift of indexing Ansel Watrous's *History of Larimer County*. She died in 1974. (M33942.)

Don P. Stimmel, Judge
A Fort Collins native and graduate of Colorado State University and the University of Colorado Law School, Stimmel became an administrative law judge in the Colorado Office of Administrative Courts, where he heard cases related to teacher tenure and other civil issues. He died in 1996; the law library in the Hearings division is named for him. (Author's collection.)

Burke Snowden, Bridge Master
By age six, Burke Snowden was playing bridge. Self-taught, he soon began playing duplicate bridge, winning both adult and youth tournaments, often with his partner, Billie Turner, shown here. In 2011, at 14, Burke became the country's youngest club director and a life master and won a trip to Shanghai. He likes the challenge, the socialization, the variety, and the learning. Although his future is undecided, it will surely include bridge. (Courtesy of Burke Snowden, Billie Turner, and Catherine Snowden.)

Albert Yates,
College President
The first African American president of Colorado State University, Dr. Albert C. Yates took the helm in 1990 and saw the university through the aftermath of a devastating flood in 1997. Over 400,000 volumes in the Morgan Library were lost. During his tenure, the university's enrollment grew, and the Colorado Commission on Higher Education honored the university. Yates left the university in 2003. (Courtesy of Albert Yates.)

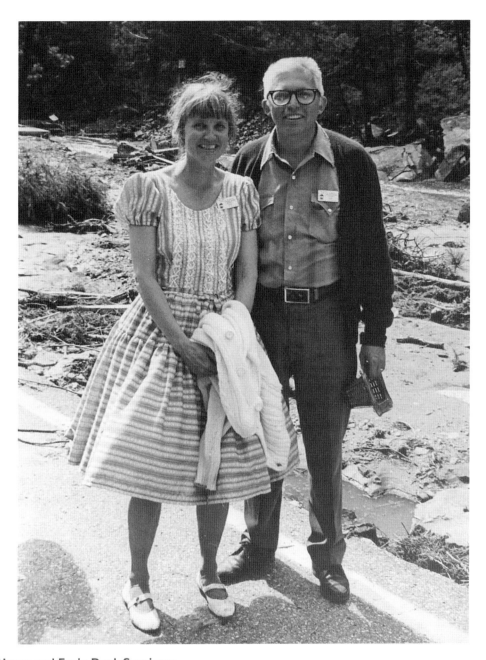

Nancy and Ervin Deal, Survivors
As Ervin and Nancy Deal headed for Estes Park on July 31, 1976, to attend a square dance, they began to encounter extremely heavy rain. Then they saw water washing over the road from the Big Thompson River, which was rapidly gathering debris. At milepost 72, they abandoned their car, which was never found, and climbed. They spent the night among other survivors, awaiting rescue, while the fierce storm gradually abated. In the photograph, they are being rescued by helicopter the next afternoon. The Deals had been caught in—and survived—a "100-year flood," which killed nearly 140 people. The Big Thompson Canyon flood was one of the most devastating in the history of Colorado. Poudre Canyon also flooded, but no one died there. (Courtesy of Karen Robinson and Ervin Deal.)

Tim Masters, "Presumed Guilty"
In 1987, a young Fort Collins woman, Peggy Hettrick, was found dead in a field near the home of young Tim Masters, 15 at the time. Masters saw her body but was unaware she was dead. Eleven years later, Detective Jim Broderick developed a circumstantial case against Masters; he was charged and convicted of first-degree murder. For a decade, Masters fought to get the conviction overturned. In 2003, attorney Maria Liu was appointed by the state as Masters's post-conviction lawyer. With her persistence and the aid of others, a scrap of cloth with DNA evidence was released by the Fort Collins Police Department, leading to Masters's release in 2008. He has since written a book about his experience. (Courtesy of Fort Collins *Coloradoan*. All rights reserved. Used by permission and protected by the copyright laws of the United States. The printing, copying, redistribution, or retransmission of this content without express written permission is prohibited.)

Byron White, Justice

From Fort Collins to the Supreme Court was the trajectory of Justice Byron White's life story. The first Coloradan appointed to the court, White met John F. Kennedy when living in Europe in 1939 as a Rhodes scholar. Valedictorian of his class at the University of Colorado, he played professional football before joining the Navy during World War II. He was appointed to the court by President Kennedy in 1962 and died in 2002. (H03315)

Elizabeth Case, "Volunteer Extraordinaire"

Throughout her married life in Fort Collins, which started in 1953, Elizabeth Case devoted herself to volunteering at Fort Collins Children's Theater, Parent-Teacher Association, the Fort Collins Historical Society, Girl Scouts and Boy Scouts, United Way, and the Poudre Landmarks Association, among others. She delivered Meals on Wheels and hosted many exchange students. She was named Community Builder of the Year in 1964 and university honor alumna in 2000. She died in 2008. (H08843.)

David Watrous, Editor
Shown here at his desk at the Fort Collins
Coloradoan, David Watrous, nephew of Ansel
Watrous, worked at the newspaper as city editor
until his retirement in 1964. He had an active
role in relocating the Pioneer Museum into the
Carnegie building, formerly the public library,
when the original museum was demolished in
1974. (H17098.)

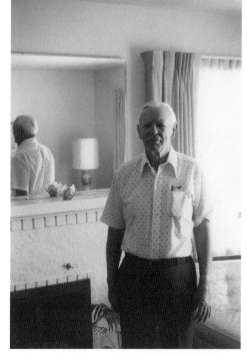

J. Ray French, Educator and Coach
J. Ray French played football on the 1927
championship team at the college and went on to
coach football at Fort Collins High School after
graduation. French helped start the recreation
program in Fort Collins. French Field at Rocky
Mountain High School, which accommodates
football, soccer, and track and field and is equipped
for nighttime use, is named for French. The field
was dedicated in 1974; students at all four high
schools here use it. (H69168.)

Karl Carson, Civic Leader
Dr. Karl Carson, a local dentist and a World War II veteran, was elected mayor of Fort Collins in 1968. He served on the first planning and zoning board and the Poudre School District board and was involved with the Capital Improvement Campaign that led to the remodeling of Lincoln Junior High School into the Lincoln Center. Named Community Builder of the Year in 1968, he said it was potholes in the streets that got him engaged in city politics. (H08841.)

Ray Martinez, Mayor
A former police officer and the first Hispanic to be promoted to sergeant in Fort Collins, Ray Martinez became the first Hispanic to be elected mayor when he won that post in 1999. He served three terms as mayor and now has a consulting firm. Martinez is the author of three books and is active on several community boards. (Courtesy of Ray Martinez.)

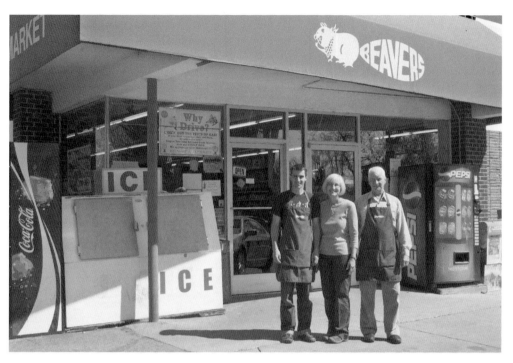

The Beavers Family, Grocers

Mom-and-pop grocery stores might seem to be a thing of the past. Not so in Fort Collins, where Beavers Market on West Mountain Avenue has served customers since 1972. The entire family, including Doug Beavers's wife, Cheryl, and their son Bryan (above, left), is in the business. With a loyal customer base and the trolley passing by in the summer, the store has become a neighborhood landmark. (Photograph by Malcolm McNeill; courtesy of the Beavers family.)

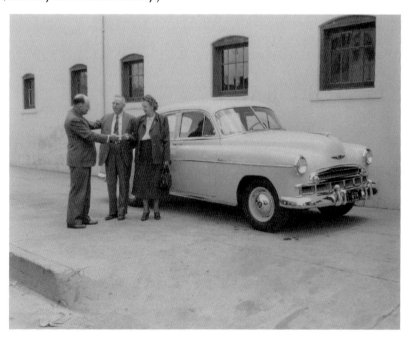

John Toliver, Merchant and More

For decades, Toliver-Kinney Mercantile downtown was the place to go for DIY supplies. John Toliver, shown to the left, and his brother Tom took over the store from their father in 1961. Toliver was much more than a merchant. In high school, he excelled in track (through which he met Jesse Owens). He later learned to fly and was a flight instructor during World War II. In his 90s, long after retirement, he could be seen jogging downtown. He died in 2011, age 98. The original store on Mountain Avenue, shown in the photograph below, was versatile, selling gasoline as well as merchandise. (Left, H10804; below, H11714.)

Walter Cooper, Car Dealer (OPPOSITE PAGE)

Walter B. Cooper, shown on the opposite page at his car dealership with Hal Henry, center, and Martha Cooper, sold Chevrolets in Fort Collins for 32 years. A songwriter as well, best known for "Where the Purple Lilacs Grow," he opened a music store and music-publishing business, Cooper Music and Appliances, on North College Avenue. He also served on the State Board of Agriculture. Cooper died in 1961. (H08448b.)

Ernestine and Edward Gallegos, Entrepreneurs
With his three sons, Edward Gallegos began Gallegos Sanitation with one truck in 1959, introducing the first automated trash truck two years later. Over the past 50-plus years, the company has grown to be an established, competitive trash hauler with innovative practices. Although owned by another company for a time, Gallegos Sanitation Inc., has been a family-owned company since 1989. Edward died in 1993, and Ernestine passed away in 2012. (Courtesy of Kari Gallegos-Doering.)

Sen. W.A. Drake, Businessman
William A. Drake owned several farms in the Fort Collins area near what is now Drake Road and South College Avenue. A wealthy man, he commissioned architect Montezuma Fuller to design a house for him on Remington Street, at a cost of $18,000 in 1908. Drake was elected a state senator in 1904. At one time, he had the largest lamb-feeding operation in Colorado; sheep farming here accounts for the university's sports name, the Rams. (H02681.)

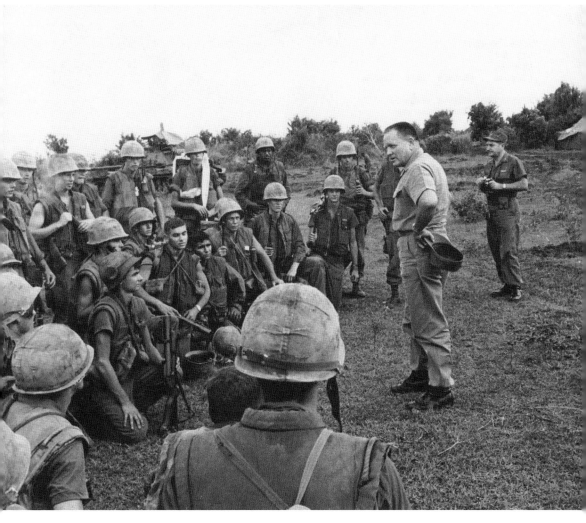

Gen. Lewis Walt, Career Soldier

Lewis Walt graduated from high school and college in Fort Collins and joined the Marines in 1936 as a second lieutenant. In 1942, Walt, by then a captain, engaged in several battles in the Pacific theater and was awarded the Silver Star for gallantry. Ordered to Korea in 1951, now a colonel, Walt commanded Marine troops and earned more medals. He was promoted to major general in 1960. Walt was a commanding general during the Vietnam War and received medals from the United States and Vietnamese governments. The general was featured in a *Life* magazine cover story in 1967. As assistant commandant of the Marine Corps in 1969, he was promoted to four-star general. Walt wrote three books after retirement and died in 1989, aged 76. In the photograph, Walt congratulates the men of G Company, 2nd Battalion, 5th Regiment, for their well-done work during the Vietnam War. (H08280.)

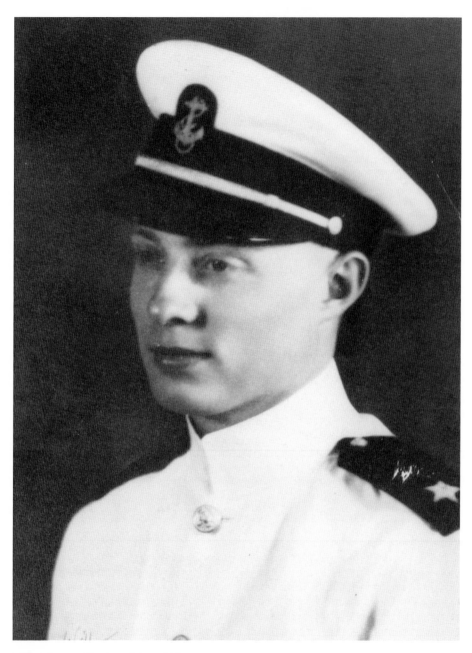

Bert Christman, Cartoonist and Hero
Born in Fort Collins in 1915, Bert Christman had ambitions of becoming a famous artist. Portfolio in hand, he went to New York City after graduating from college. Eventually hired by the Associated Press as a general artist, he took over drawing the popular *Scorchy Smith* cartoon strip, a tip of the hat to Charles Lindbergh, in 1936. By 1938, attracted by aviation, he joined the Navy as an aviation cadet. Christman continued his art with the burgeoning comic book industry. In 1941, with China facing invasion from Japan, an American volunteer group of pilots was formed, trained by Claire Chennault, to keep the Burma Road open. When war broke out, Chennault's Flying Tigers were mobilized. Christman was killed on a mission in January 1942; he was shot as he bailed out of his airplane. He is buried in Fort Collins. (H25152.)

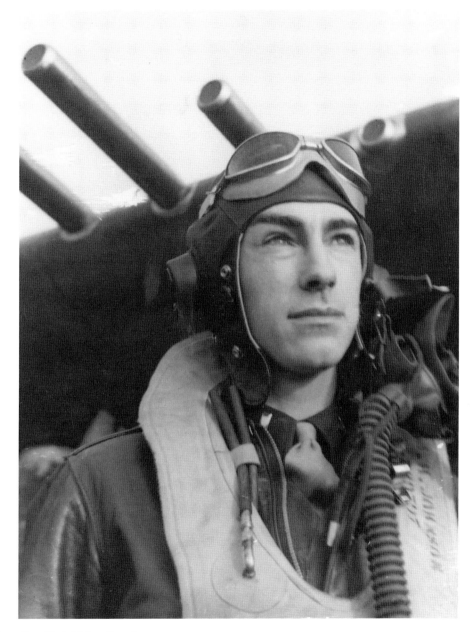

Courtlyn Hotchkiss, Survivor
Courtlynn Hotchkiss, a graduate of the college, had enlisted in the Civilian Pilot Training Program before World War II and, after the United States entered the war, was in one of the first flight squadrons over Europe. Early in 1944, before D-Day, he was shot down in France and parachuted out of the plane. Helped by a sympathetic farmer, he escaped capture and joined the underground, getting a new name and identity. He managed to make it to Paris in time to see Charles de Gaulle enter through the Arc de Triomphe. Encountering an officer in a state of shock, he offered to help the man get medical assistance, and in gratitude, the officer helped him get to Omaha Beach and from there to England, where he sent a telegram to his family. They had been told Hotchkiss was missing in action and then that he had been killed. (H16940.)

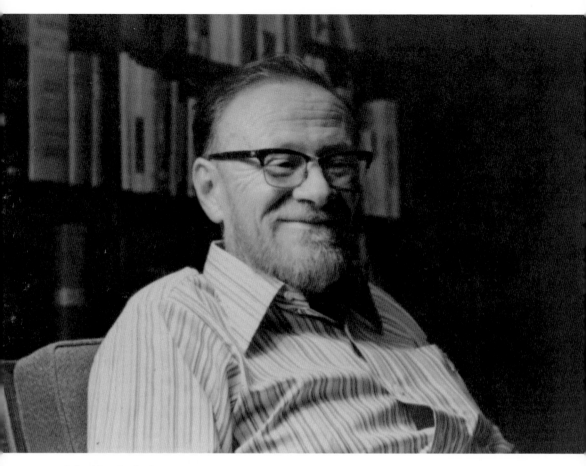

John Mattingly, Inventor
John Mattingly came to Fort Collins to work at Heath Engineering in 1949. During his employment there, he developed several innovative products for the company. He designed and built a family home with a basement area that became his workshop. After he left Heath Engineering, working as a consulting engineer, he embarked on a partnership with the Mattingly family's dentist, Dr. Gerald Moyer, who had long wanted Mattingly to create a usable oral hygiene appliance. Coordinating their respective skills and improving on an earlier design by another dentist, the two men fashioned the Water Pik. Investors were found, and the company that made John Mattingly a millionaire started manufacturing the device in the early 1960s; it is still located in Fort Collins today. (Courtesy of David Mattingly.)

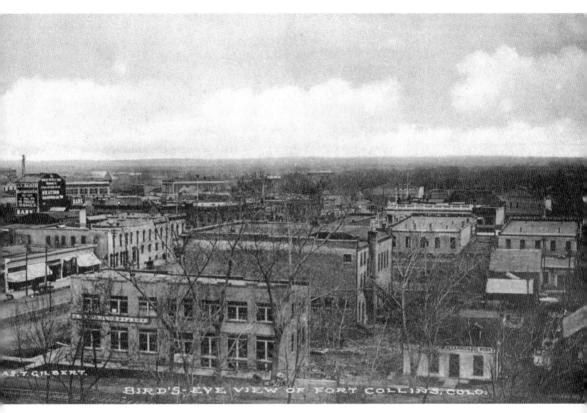

Harper Goff, Designer

The view of downtown Fort Collins shown here is one Harper Goff was familiar with in childhood. His father owned the local newspaper, and Goff, born in 1911, was taken with the 19th-century buildings. After studying design in Los Angeles, he worked in New York City. During World War II, he designed camouflage hues for the Army. In 1951 Goff, a model train enthusiast, met Walt Disney when they both wanted the same train. Goff worked for Disney's artistic team and designed the exterior of the *Nautilus* used in 20,000 Leagues Under the Sea. When Disney embarked on building his first theme park in California, Goff used his photographs and memories of downtown Fort Collins, along with buildings in Disney's hometown, to design Main Street in Disneyland. Goff died in 1993. (H21170.)

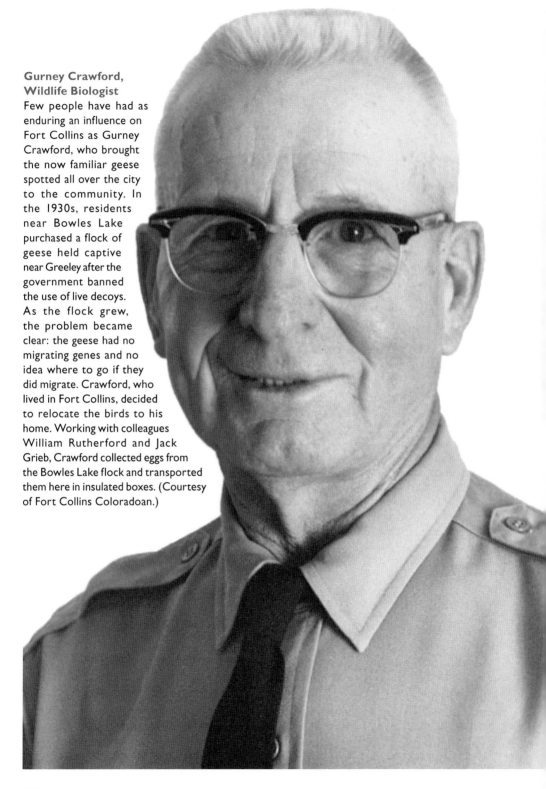

Gurney Crawford, Wildlife Biologist
Few people have had as enduring an influence on Fort Collins as Gurney Crawford, who brought the now familiar geese spotted all over the city to the community. In the 1930s, residents near Bowles Lake purchased a flock of geese held captive near Greeley after the government banned the use of live decoys. As the flock grew, the problem became clear: the geese had no migrating genes and no idea where to go if they did migrate. Crawford, who lived in Fort Collins, decided to relocate the birds to his home. Working with colleagues William Rutherford and Jack Grieb, Crawford collected eggs from the Bowles Lake flock and transported them here in insulated boxes. (Courtesy of Fort Collins Coloradoan.)

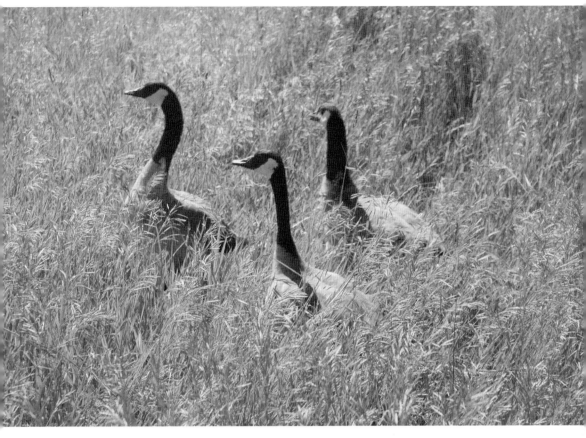

Crawford's Legacy
Shown here ambling about in Spring Creek Park, these geese are a small portion of the descendants of the successful goose transfer. Bantam hens hatched the original eggs; later, incubators took over. Young Canada geese began appearing around town, but predators were taking the eggs, so Crawford built nesting platforms mounted on poles. As the flock grew and thrived, migrating geese started stopping by. Many chose to winter here, where there was plentiful food and less danger from hunters. Some never left. By the 1970s, it was estimated that Fort Collins had about 2,000 resident geese. Though Crawford died three decades ago, his legacy lives on. (Courtesy of Colorado Division of Wildlife.)

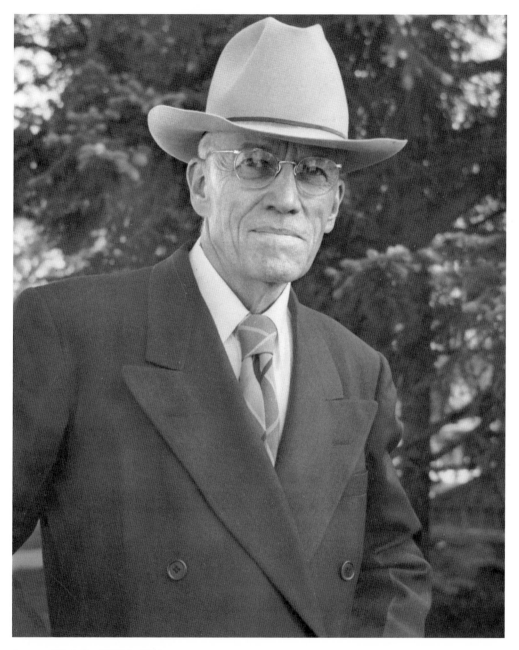

Lyman Nichols, Reticle Maker
Reticles are pieces of glass etched with acid, used, for example, in bombsights, in detecting forgeries, in telescopes, and in rifles. Lyman Nichols made reticles for 40 years. Nichols, who came from New Jersey, was born in 1895 and served as an infantry officer in World War I. Fascinated by microscopic subjects, he joined the New York Microscopial Society and began working in the field in the 1940s. Many of his reticles were used during World War II, including for the plane Jimmy Doolittle flew over Tokyo in 1942. He also was interested in micro-writing, such as inscribing the Lord's Prayer on a space the size of the head of a pin. Nichols and his wife moved to Fort Collins in 1951; after moving here, he made parts for Skylab. He died in 1983. (H11041.)

John Matsushima, Animal Scientist

Dr. John Matsushima was named 2013 Citizen of the West. In 2009, he received the prestigious Japan Emperor Award in Tokyo, the first Japanese American to do so. A native Coloradan, Matsushima taught animal science at Colorado State University, his alma mater. Growing up on a farm near Lafayette, Matsushima was familiar with animals and interested in their welfare. During his career here, he developed a method of feeding cattle that increased the nutritive and digestive properties of grain. The steam processing technique he pioneered for feed grains has reduced the cost of cattle feeding worldwide. The emeritus professor has consulted on cattle feeding in numerous other countries. Matsushima has written a book about his life. (Courtesy of John Matsushima.)

Eddie Hanna, Athlete

Eddie Hanna, one of the first black athletes at the college, was a World War II veteran who served in the Air Force and took advantage of the GI Bill to get a college education. He enrolled at the college in 1947. Small and light, he proved speedy on the football field and was a favorite with fans. On a clear fall day in 1949, the college team played in Colorado Springs against Colorado College. With the score 7-7 in the fourth quarter, Hanna, who had said the day before he was not feeling up to par, made a touchdown, giving the Aggies the win. When the team and the fans boarded the chartered train to head home, Hanna suddenly complained of burning in his chest. He collapsed and died on September 17, 1949. He was 24 years old. (Courtesy of CSU Athletic Department.)

Bill Green, Basketball Player
William E. "Bill" Green played basketball for CSU between 1960 and 1963. At six feet, six inches, Green was the university's first All-American. An outstanding player, he achieved school records that still stand. After graduation, the Boston Celtics, the Boston Red Sox, and the Dallas Cowboys drafted him. Unfortunately, Green could not overcome his fear of flying, ending a career in professional sports; he became a teacher. (Courtesy of CSU Athletic Department.)

Becky Hammon, Basketball Player
At 35 in 2012, Becky Hammon was still playing professional basketball in the Women's National Basketball Association. At CSU, she was an All-American and named Colorado Sportswoman of the Year. She set many enduring records. Her jersey, No. 25, has been retired, and she is in the CSU Sports Hall of Fame. (Courtesy of CSU Athletic Department.)

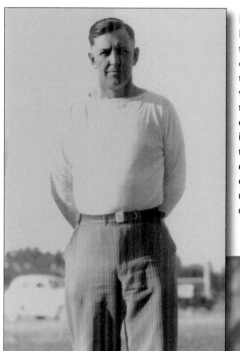

Harry Hughes, Coach
Harry Hughes came to the college to coach football in 1911. A strict disciplinarian, he expected his players to toe the line off the field. Hughes was responsible for the building of the first sodded athletic field on the campus, found on College Avenue, in 1912. During his coaching career, the team won eight collegiate championships. In 1942, he became director of athletics, a post he held until retirement in 1953. (Courtesy of CSU Athletic Department.)

Sonny Lubick, Coach
Between 1993 and 2007, football coach Sonny Lubick's teams won six conference championships and played in nine bowl games. In 1994, *Sports Illustrated* named Lubick Coach of the Year. Lubick has been honored by the local community for his leadership and character and, in 2009, was inducted into the Colorado Sports Hall of Fame. (Courtesy of CSU Athletic Department.)

Felix Martinez, Baseball Player
Felix "Tippy" Martinez, a Colorado native, played baseball so well at CSU that he was offered a contract with the Washington Senators. A left-handed pitcher, he signed first with the New York Yankees, then was traded to the Baltimore Orioles, where he played until retirement. At one game in 1983, he picked off three first base runners in one inning. He was part of the Orioles' world championship team the same year. (Courtesy of CSU Athletic Department.)

Jim Williams, Basketball Coach
Jim Williams, the men's basketball coach for 25 years, led the Rams to four National Collegiate Athletic Association tournaments, including reaching the final eight in 1969. During the construction of Hughes Stadium and Moby Arena, Williams was athletic director. Until 2009, he held the record for most games won (352) by any coach, in any sport, at CSU. (Courtesy of CSU Athletic Department.)

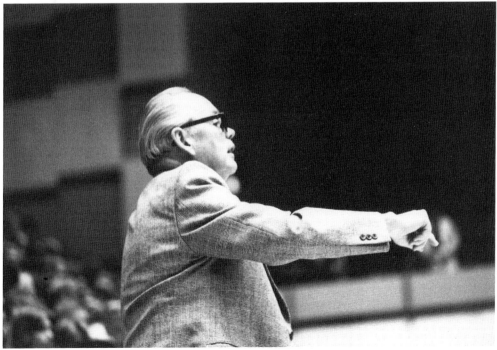

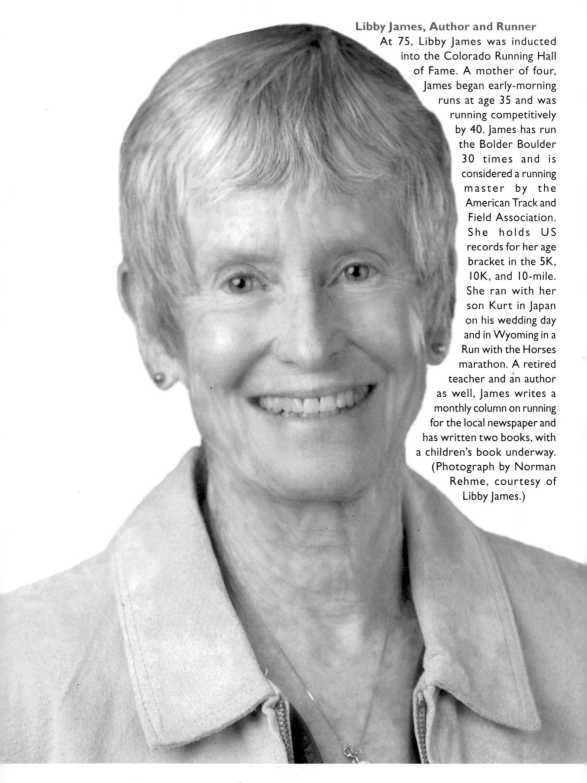

Libby James, Author and Runner
At 75, Libby James was inducted into the Colorado Running Hall of Fame. A mother of four, James began early-morning runs at age 35 and was running competitively by 40. James has run the Bolder Boulder 30 times and is considered a running master by the American Track and Field Association. She holds US records for her age bracket in the 5K, 10K, and 10-mile. She ran with her son Kurt in Japan on his wedding day and in Wyoming in a Run with the Horses marathon. A retired teacher and an author as well, James writes a monthly column on running for the local newspaper and has written two books, with a children's book underway. (Photograph by Norman Rehme, courtesy of Libby James.)

Greg Campbell, Journalist

After serving as editor in chief of the *Boulder Weekly* and covering the war in Kosovo, Greg Campbell co-founded the *Fort Collins Weekly* newspaper in 2002. He was the newspaper's editor for six years. Campbell has written several nonfiction books, including *Blood Diamonds*, which was the basis for the film, *Blood Diamond*, starring Leonardo DiCaprio. His work has been in major publications such as *Atlantic Monthly*, and he recently published a book about marijuana. (Courtesy of Greg Campbell.)

Fred Blumenthal, Policeman

Fred Blumenthal began his career of public service in 1917 as a police patrolman. He worked his way up the ranks to deputy chief and then chief. He was police chief in the 1930s, during the era of bootlegging liquor, and once poured illegal liquor down a sewer. Arsonists tried to burn down his house. He retired as police chief in 1944 and died in 1969. (H02765.)

BIBLIOGRAPHY

Ahlbrandt, Arlene. "Journey of My Life." private memoir, 2004.

——— and Mary Hagen. *Women to Remember of Northern Colorado*. Fort Collins, CO: Azure Publishing, 2001.

———. *101 Memorable Men of Northern Colorado*. Fort Collins, CO: self-published, 2002.

Bohning, Larry. "Profiles of Success: Stuart 'Stu' VanMeveren." *The Colorado Lawyer*. May 2000, pp. 15–18.

Fleming, Barbara. *Fort Collins: A Pictorial History*. Virginia Beach, VA: The Donning Company, 1985, 1992.

Geller, Robert with Libby James. *Red Ribbons*. Fort Collins, CO: Geller Center for Spiritual Development, 2008.

Hensen, Dr. Stanley. *Touching Lives*. Fort Collins, CO: self-published, 2004.

Kates, Carol Ann. *Secret Recipes from the Corner Market*. Fort Collins, CO: Penny Lane Press, 2006.

Matsushima, John. *Broad Horizon—I Fear No Boundaries*. Amazon Books, 2012.

Mattingly, John. "A Few Memories." personal memoir about his father, John Mattingly.

Mattingly, Phyllis. *No Vaseline on My Teeth*. Fort Collins, CO: StyleMedia Publications, 2004.

Mefford, Jack, Janet Sanders-Richter, and Jan Weir, eds. *Hardships and Hope*. Fort Collins, CO: Midland Federal Savings, no date given.

Swanson, Evadene. *Fort Collins Yesterdays*. Fort Collins, CO: self-published, 1976.

Tresner, Charlene. *Streets of Fort Collins*. Fort Collins, CO: McMillen Publishing, 1977.

Watrous, Ansel. *History of Larimer County*. Fort Collins, CO: Old Army Press, 1972 reprint.

INDEX

AN IMPRINT OF ARCADIA PUBLISHING

Find more books like this at
www.legendarylocals.com

Discover more local and regional history books at
www.arcadiapublishing.com